IMAGES
of America

FREDERICK COUNTY

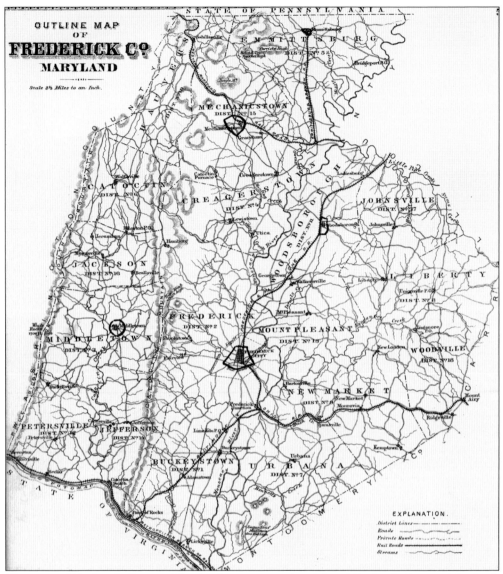

This map of Frederick County, Maryland, appears in the *Atlas of Frederick County, Maryland,* published by C.O. Titus and Company in 1873. By the 1870 federal census, Frederick County was the state's second most populated county, with 47,572 persons. The city of Frederick, with a population of 8,526, had the county's highest concentration of people; Myersville, with 139, had the smallest.

IMAGES
of America

FREDERICK COUNTY

The Historical Society of Frederick County

ARCADIA
PUBLISHING

Published by Arcadia Publishing
Charleston SC, Chicago IL, Portsmouth NH, San Francisco CA

Printed in the United States of America

Library of Congress Catalog Card Number: 2004117479

For all general information contact Arcadia Publishing at:
Telephone 843-853-2070
Fax 843-853-0044
E-mail sales@arcadiapublishing.com
For customer service and orders:
Toll-Free 1-888-313-2665

Visit us on the Internet at www.arcadiapublishing.com

CONTENTS

ACKNOWLEDGMENTS

This book project is made possible by the efforts and enthusiasm of a number of individuals. The Historical Society of Frederick County offers its appreciation to its staff for providing much of the research and writing for the book. Staff members Jennifer Boston, Julie Bryan, Heidi Campbell-Shoaf, Joyce Cooper, Duane Doxzen, Mark Hudson, and Marie Washburn cheerfully gave many hours to working on the project, over and above their other responsibilities and deadlines. Ron Marvin assisted with the selection of images.

The Historical Society's appreciation also is extended to others who volunteered their time and knowledge to complete the book. Historical Society library volunteers Nancy Lesure, Mary O'Donnell, Mary Rogers, and Paul Spofford, and museum intern Kirsten Kay contributed to research and writing of captions. Paul Gordon, Carroll Hendrickson, and Gil House provided helpful insights and information.

Many thanks go to volunteer and computer guru Bernie Becker, who worked countless hours scanning the images for the book. John Reynolds provided assistance with the images as well. The Society also thanks Lauren Bobier, our editor at Arcadia Publishing, for her encouragement, guidance, and patience throughout the process.

Finally, we thank all those who have provided for the preservation of these and other local historical images by donating them to the Historical Society's collection. These individuals have added immeasurable depth to our understanding of our history and ensure that these important images will be available for many generations to come.

INTRODUCTION

Frederick County, Maryland, is often referred to as the "Crossroads of American History," and there is much to argue in favor of the appellation. In 1765, 12 judges of Frederick County's court openly defied the British Parliament's Stamp Act, marking one of the earliest acts of contempt against the British in the American colonies leading to the War for Independence. During the Civil War, the Battles of Monocacy and South Mountain were fought on county soil, which also was trod by soldiers going to and from the nearby battles of Antietam and Gettysburg. These and other notable events and people, as well as the convergence of the National Road, C&O Canal, and B&O Railroad, make Frederick County an important resource for exploring our nation's history.

Established from a portion of Prince George's County by an act of the Maryland General Assembly on December 10, 1748, Frederick County can trace its settlement to the early 18th century. In 1732, Maryland began offering incentives that drew settlers from neighboring regions. German settlers came from Pennsylvania, and English and Scots migrated from Virginia and southern Maryland, bringing with them their own customs and beliefs. Free African Americans established themselves throughout the county, and slaves worked and endured here until that "peculiar institution" was wiped away. These and other peoples and influences have created a truly rich heritage.

The Historical Society of Frederick County was founded in 1892 to keep our local history alive. Today, the organization is actively engaged in preserving the photographs, documents, and material culture that help define that history. But that is only half its mission; the Historical Society also is committed to sharing our heritage through programs, exhibitions, tours, and publications like the one you hold in your hands.

We are pleased to present this glimpse into Frederick County's past, featuring images drawn from the Historical Society's own extensive collection. This presentation is intended to provide interesting, sometimes amusing, often fascinating, illustrations that remind us of those people and places that have come before. They form an album of "snapshots" from our past rather than a pictorial history—more an hors d'oeuvre to whet the appetite than an entrée to fill you up. Hopefully, this will just be one stop on your journey of discovery of our community's past.

The images presented here represent everything from studio portraits, to publicity shots, to amateur photos. The eclectic mix includes both the unique and the well-known. A number of the photographs were taken by members of the Byerly family. Jacob Byerly opened a studio in 1842, becoming Frederick's first professional photographer. In 1868, he sold the business to his son, John Davis Byerly, who operated it until 1899, when he, in turn, passed it on to his own son, Charles. Charles Byerly carried on the family business until 1915. Together, these prolific artists provided us with some of the best local images extant from the advent of photography through the early 20th century.

Many of the photographs from the 1940s to 1960s used in the book are the work of Frank J. Keefer, who was a respected *Frederick News-Post* photographer and freelancer. Several mid-20th-century images were taken by Nicholas Yinger, a Fredericktonian and amateur photographer who included interesting, sometimes whimsical, notes on the backs of his photos. We are fortunate to have the opportunity to share the work of these individuals as well as other professional and amateur photographers.

The effort to include images covering a large geographic area, over a considerable period of time, in a limited space, was both exciting and challenging. Images in the Historical Society's collection relating to the city of Frederick, the county seat, are, not surprisingly, more numerous and so necessarily make up many of the illustrations presented in the book. However, the Society's focus is neither limited to Frederick nor to one particular racial or ethnic group. We hope that this book will encourage individuals from throughout Frederick County to consider how best to preserve their own photographs for posterity.

Whether you are a life-long resident of Frederick County or just passing through, we hope that you will be informed and entertained by this collection. We also invite you to experience more of the county's history by visiting the Historical Society's museum, research library, and Roger Brooke Taney House, or by attending the many educational programs, activities, and events offered by the Society throughout the year.

Duane Doxzen
Book Project Manager

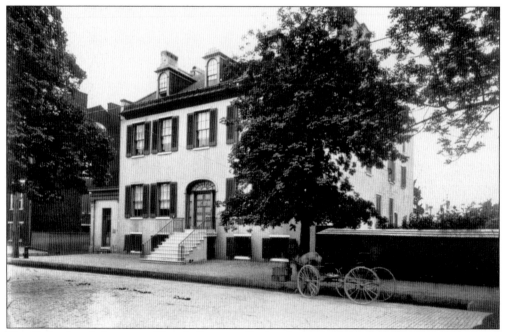

This Federal-style home on Church Street in Frederick was built by Dr. John Baltzell in 1820. It subsequently served as residence to the Hanson and Loats families. The Loats Female Orphan Asylum was operated here from 1882 to 1956. Purchased by the Historical Society of Frederick County in 1959, the building now houses a museum dedicated to Frederick County's history and a research library, and it hosts public programs throughout the year.

One

FARMING

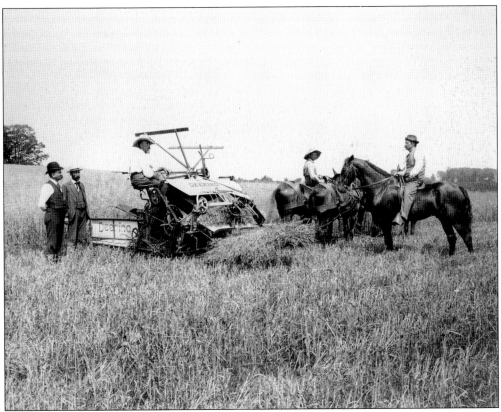

Prominently featured in this carefully choreographed photograph, taken by Charles Byerly about 1905, is the Deering grain binder. Grains and corn have been the predominant crops grown throughout Frederick County since its earliest settlement.

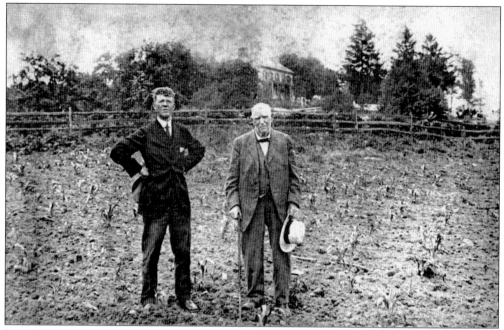

Roy Hyndman (left) and George William Smith are seen in this *c.* 1900 photograph in a field at Prospect Hill Farm, located southwest of Frederick. Smith was the second owner of the property and lived there during the Civil War. His diary is rich in detail about events on the farm in the days leading to the Battle of Gettysburg. Hyndman later owned Prospect Hill and resided there for many years.

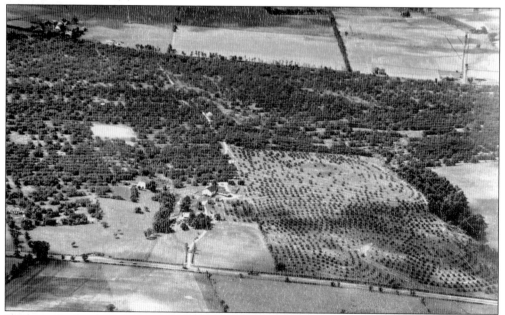

Hillcrest Orchard was owned by E. Dwight McCain. McCain was president of the State Horticultural Society in 1928–1929 and hosted some of the organization's meetings at his orchard. Apples as well as peaches were grown at the orchard, which was located on the south side of Route 40 in Frederick. The hillside afforded the trees protection against frost.

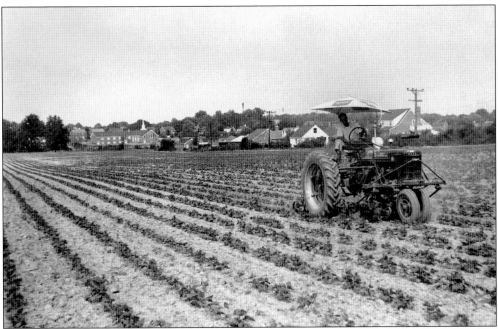

Russell Kidd, of Braddock Heights, "hills" string beans on a parcel of the Fred Krantz farm in Frederick on July 14, 1957. The 70 acres was rented by Jenkins Bros. Canners for $700 a season. Nicholas Yinger, the photographer, reported, "Very few if any Mexican bean beetles as yet." He also noted that he had found hundreds of Indian relics in this field over the past 50 years.

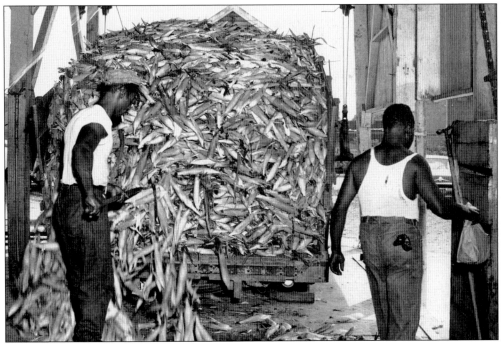

Men unload a truckload of corn into a corn crib, perhaps at the Southern States Co-op in Frederick, in the 1950s. Corn has been grown in the county since its earliest settlement. In 1828, Frederick diarist Jacob Engelbrecht recorded that he had paid $1.75 for a barrel of corn.

A Quynn-Riley aerial photographer caught dozens of cars and trucks (foreground) parked at Mrs. Nellie Thrasher's farm in Jefferson early on August 18, 1948. They belonged to just a few of the 500 workers and over 40,000 spectators who flocked to the property to effect a transformation. Mrs. Thrasher, a widow, and her two teenaged sons lived and worked on the 175-acre farm that was sorely out of date. In an effort to illustrate new methods of agriculture and soil conservation, as well as to help a member of the community, the Frederick County Pomona Grange conceived and coordinated the day-long event. Modeled after similar projects sponsored by the U.S. Soil Conservation Service, the Grange enlisted the help of local farmers and businesspeople and the Maryland National Guard to completely overhaul the farm in just one day to make it more profitable and environmentally friendly. At the end of the day, new fencing, a new dairy barn, an acre-sized fish pond, pastures, and rotation crops planted in contoured fields were complete.

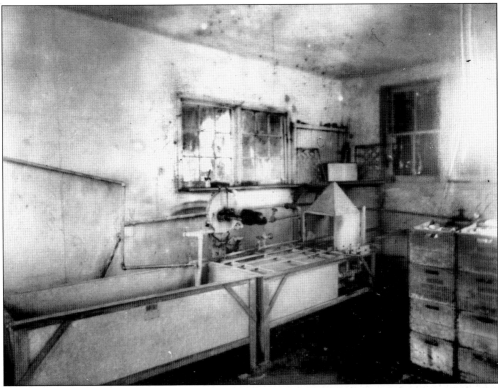

In the early 1900s, this gleaming milk bottle washing and sterilizing equipment could be found at Locust Level Farm. The 200-acre farm was located just south of Frederick on present day Route 355. Not only did the farmer, Ransom Rush Lewis, own one of the finest herds of cattle in Frederick County, he also served as president of the First National Bank of Frederick and co-owned the G.L. Baking Company.

An unidentified local dairy farmer pouring milk into a surface cooler was captured by Frederick photographer Frank Keefer in the 1950s. Milk straight from the cow was poured into a basin on the cooler's top, which was cooled with water, and then was directed over the lower coils, where iced water or direct cooling was applied. The milk was captured in milk cans and readied for transport.

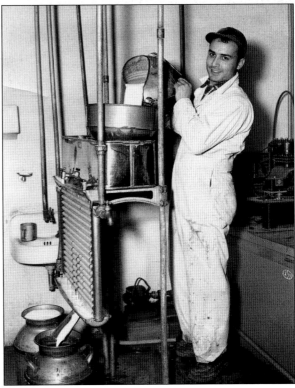

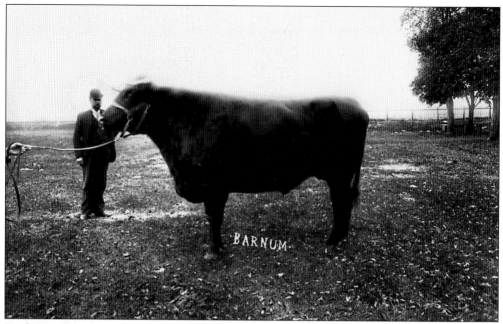

By the time this photo was taken about 1900, agricultural shows had taken place in Frederick County for many years. The importance of local agriculture was marked by the creation in 1820 of the Agricultural Society, whose purpose was to improve agriculture in the county. Someone must have been particularly pleased with "Barnum" the bull, truly a fine specimen.

On May 22 and 23, 1822, Frederick County's first cattle show was held at George Creager's Tavern at Monocacy Bridge near Frederick. The Frederick Fair has been held every year since, except during the Civil War, World War I, and World War II. This *c.* 1890 photo was taken at the fairgrounds on East Patrick Street, which were purchased by the Agricultural Society in 1868.

Local grower Joe Fogle of Walkersville proudly displayed two heads of cabbage he grew, one weighing 20 pounds and the other 40 pounds, c. 1960s. Farmers and other Frederick Countians still exhibit great pride in the county's long agricultural history and continued excellence, highlighted annually at the Great Frederick Fair.

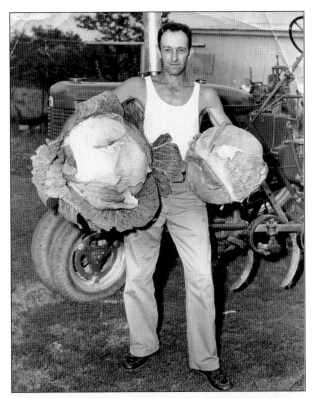

Earl B. Wiles of the Utica area of Frederick County points out a display of pumpkins—very likely at the Frederick fair—to Daniel, age four, and James, age two, in this photograph. A 1957 newspaper advertisement listed him as a dairy farmer who supplied milk to High's Dairy at a time when a gallon of milk cost local consumers just 82¢ a gallon.

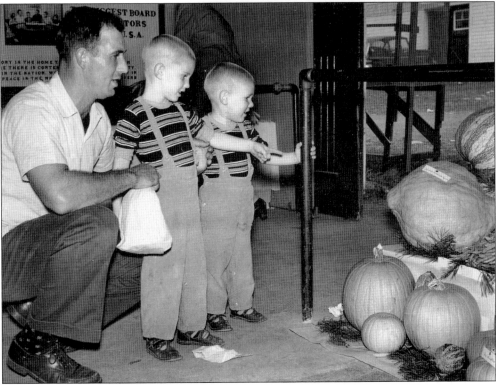

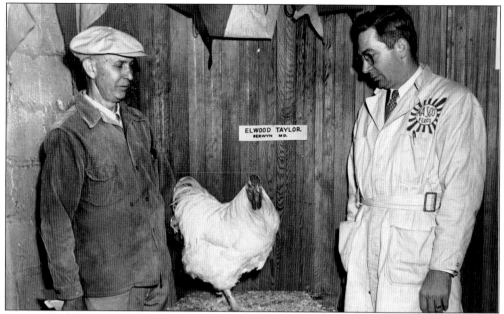

Elwood Taylor (left) of Berwyn, Maryland, looks with pride on his prize-winning chicken at the Great Frederick Fair in 1947. The fair draws individuals from throughout the region to compete as well as attend. R. Kenneth Fry of Smithsburg, wearing a Kasco Feeds jacket, was in charge of the Poultry Department.

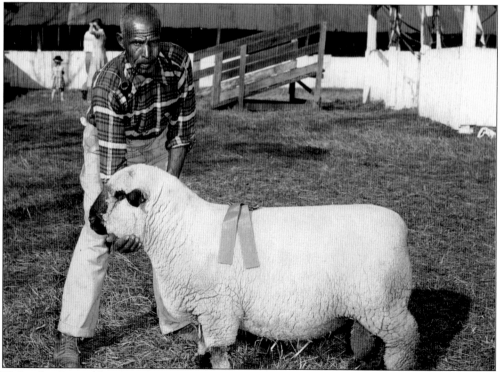

T. Gordon Bautz of Lutherville, Maryland, poses with his grand champion Hampshire ewe at the Frederick fair on October 3, 1956. He also owned the grand champion ram at the fair that year.

Robert Renn Jr. of the Monocacy 4-H Club poses with his 18-month-old pet Holstein cow at the Great Frederick Fair. Throughout the county's history, organizations such as the Grange, Agricultural Society, 4-H, and Future Farmers of America have worked to impart practical farming skills and instill a sense of the county's agricultural heritage to youth.

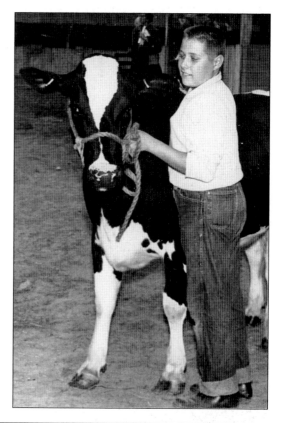

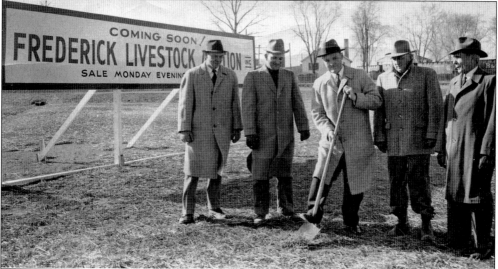

Frozen ground was broken in January 1959 for the construction of the Frederick Livestock Auction by, from left to right, Jack Garrott, business president; Jack Starliper, auction manager; Frederick mayor Jacob R. Ramsburg; John Renn, livestock dealer; and Henry Shoemaker, county agent. The auction provided a place for county farmers and livestock dealers to conduct business and socialize until the auctioneer called his final sale at the stockyard in November 2001.

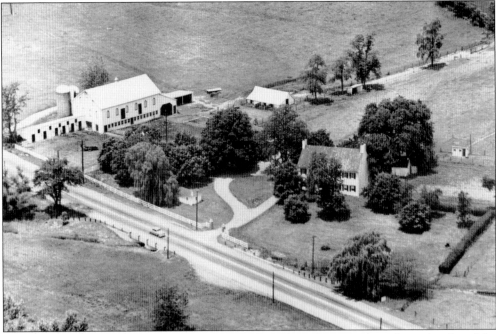

Through the years, many acres of land previously under cultivation have been developed for other uses. This aerial view shows the farmhouse and other structures on the Elmwood Farm on the National Pike west of Frederick. At the time of this photo, the farm was owned by Charles and Philip Wertheimer. It is now the site of Frederick Towne Mall on the "Golden Mile."

The barn, silo, and house of the J.B. Hayward Farm are seen in this undated image. Located immediately west of U.S. Route 15, these structures are today part of the Frederick County Public Schools complex on Hayward Road.

18

Two

DOING BUSINESS

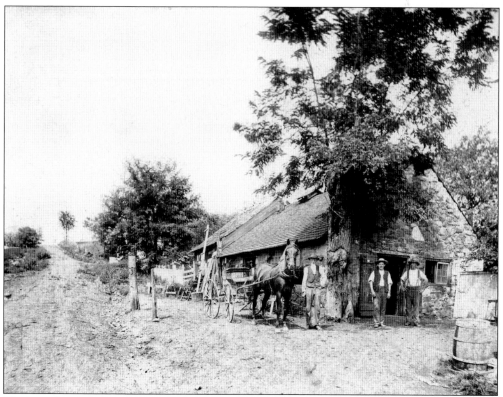

Blacksmiths worked with iron to make tools, hinges, wagon-wheel rims, nails, barrel hoops, and other items for the home and farm. Shown here is Woodsboro's second blacksmith shop, owned by the Donsife brothers. Dan Zimmerman (left) stands next to a horse and cart; Francis Genoa Donsife (center) and Atho Donsife (right) stand in front of the shop.

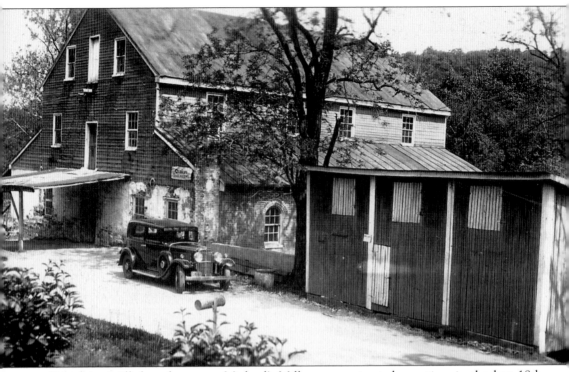

Delaplaine Mill, later known as Michael's Mill, was constructed sometime in the late 18th century on the Monocacy River near Buckeystown. By 1842, the mill complex included a sawmill, gristmill, warehouses, stable, and copper shop, as well as slave quarters. From 1851 to 1876, it was owned by Theodore Delaplaine. Despite several devastating fires and the appropriation of 700 barrels of flour by the Confederate army during the Civil War, the mill prospered under Delaplaine's ownership. The mill was sold to the Steiner family in 1906. Leo Michael, who married Edna Steiner, eventually took over its management. The mill was doing a business of $40,000 a year in 1940, about the time this snapshot was taken. It remained in operation until 1957.

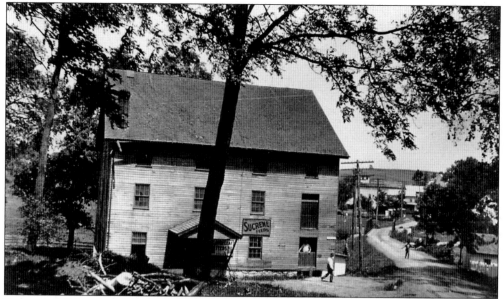

Between 1790 and 1870, a number of mills, including textile, grist, and flour mills, grew up in the Monrovia area along Bush Creek, a tributary of the Monocacy River. This Monrovia gristmill was built on the foundation of the old David Reinhart Mill. The Reinhart Mill appears on the 1858 Isaac Bond map of Frederick County.

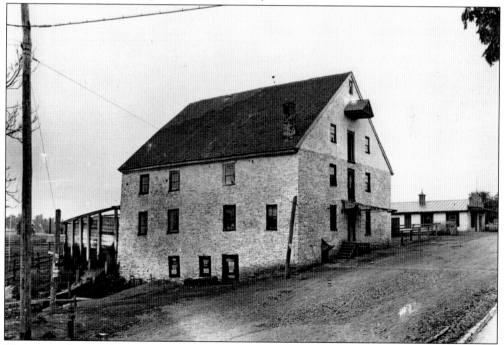

This stone flour and grist mill stood on North Bentz Street of Frederick in the area of the modern playground near the William B. Talley Recreation Center, the old Armory building. It was built in the last quarter of the 18th century. Water diverted from Carroll Creek through a millrace powered the mill, known variously as the Zentz or Frederick City Mill. Fire gutted the building about 1926.

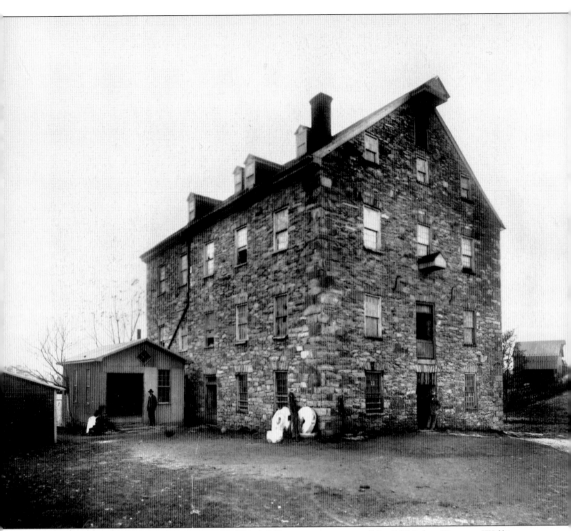

Ceresville Mill, later known as Kelly's Mill, was constructed in 1813 by George Williams on 600 acres along Liberty Road. The mill replaced an earlier c. 1790 mill, among the first to be built in the county, and thrived under the Shriner family throughout the 19th and early 20th centuries. Known for its manufacture of Snow Drift and Pure Gold flour, it processed 100,000 bushels of wheat in 1910. Flour, corn meal, hominy, and stock feed all were manufactured at the mill. In 1947, the business was sold to the Kelly family, which operated it for another 40 years. Kelly's Mill ceased operation in 1988, and the six-story building now stands empty, the only extant stone mill in Frederick County.

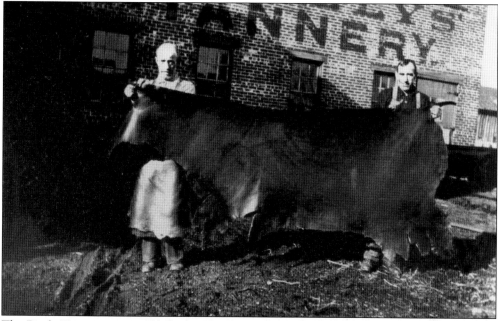

The Birely Tannery was established in Frederick about 1820. Tanning was a common industry throughout the county in the 19th century. Here, two workers display a cowhide c. 1909.

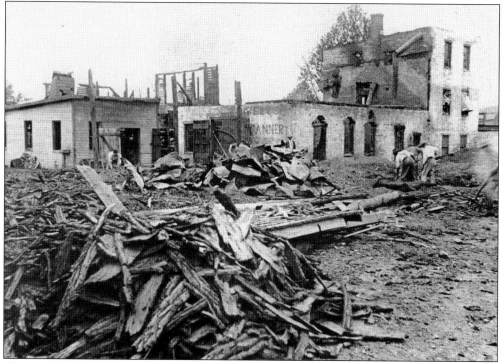

The Birely Tannery was damaged by fire in 1909. In this image taken after the fire, a pile of hides can be seen at the center; a pile of bark, used for the extraction of tannic acid to treat the hides, is visible in the foreground. A group of men at right clean up debris standing amid wooden water pipes.

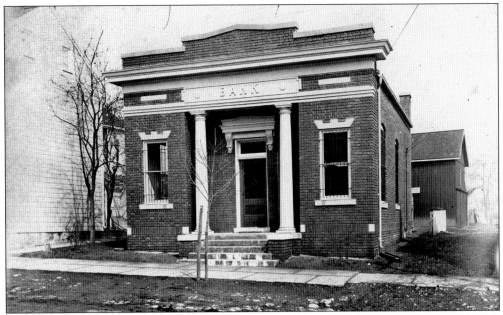

The Jefferson Bank opened in 1916 on the Jefferson Pike as a branch of the Commercial Bank of Maryland. The bank's board elected Albert Bussard as its first cashier. In 1938, the bank was purchased by Western Maryland Trust Company, which subsequently merged with Maryland National Bank in 1968. Jefferson Bank experienced its first robbery in 1954, the robber first getting $720 and then being nabbed shortly after.

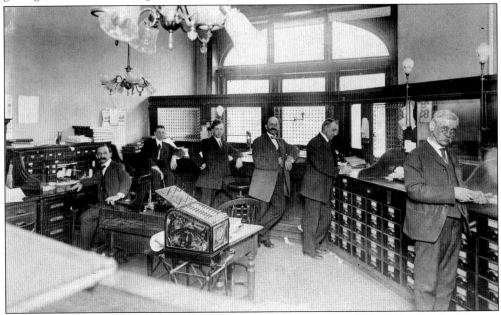

Farmers and Mechanics Bank started as a branch of the Bank of Westminster in 1817 and opened on the corner of Second and Market Streets in Frederick. This was the bank's location for over a century, although buildings on this spot were torn down and rebuilt several times. Later, F&M merged with Citizens National Bank and moved to the southeast corner of Patrick and Market Streets, where it is today.

The Frederick County National Bank was established in 1818. The bank building was originally a two-story structure; the top story shown in this c. 1905 photo was added in 1898. Located on the northwest corner of Market and Patrick Streets in Frederick, this building was demolished in 1898 and a new building was constructed, which was expanded in 1992. It is now owned by BB&T Bank, which purchased FCNB in 2001.

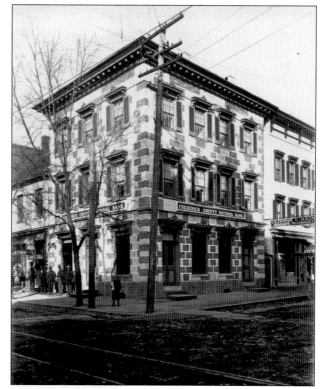

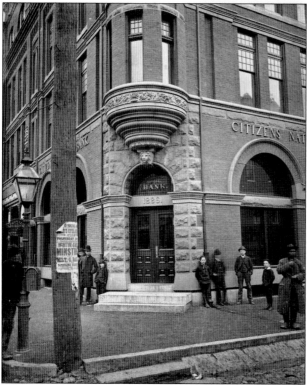

Citizens National Bank was established in 1886 on the corner of Patrick and Market Street in Frederick. The building in this photo was torn down in 1908–1909 and replaced with an expanded building. In 1953, the bank merged with Farmers and Mechanics Bank, which relocated to this site.

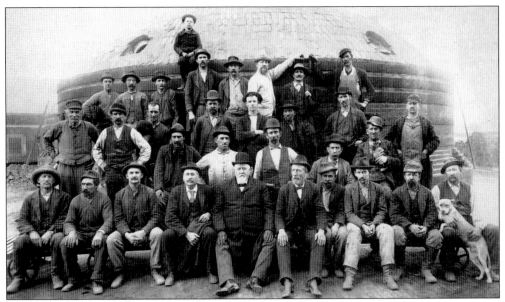

Employees and executives of the Frederick Brick Works pose in front of a brick kiln for this *c.* 1890s Byerly photograph. Incorporated in 1891, Frederick Brick Works manufactured "Frederick Reds," popular building materials used locally as well as in Baltimore and Washington. Raw clay was mined by hand and formed into bricks, which were then fired in kilns. Finished bricks were hauled by horse- and mule-driven wagons.

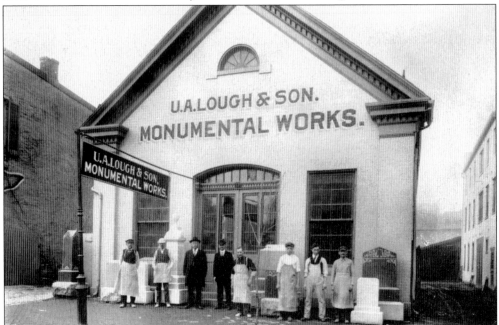

U.A. Lough & Son Monumental Works was established in 1874. Also known as Lough Excelsior Monumental Works, the business created granite and marble monuments, headstones, street curbs, and iron railings. In an 1884 ad in the Frederick *Weekly News,* Lough & Son claimed to be the "sole agents for four counties in this state—Montgomery, Frederick, Carroll, and Howard." The company is still creating monuments today.

John Eisenhauer started his grocery business in 1863 on the corner of Second and Market Streets in Frederick but moved it farther north on Market Street five years later. He sold oil lamps, imports from China, and earthenware pots and ironstone from England. Eisenhauer's was in business at this location for over 100 years. John Eisenhauer is the bearded man at left in this photograph, probably taken in the 1880s.

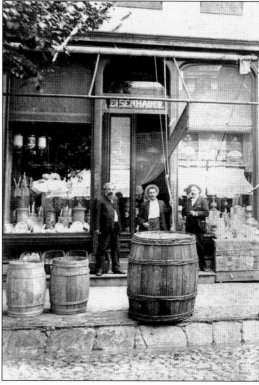

Measell's was located on East Patrick Street in Frederick and operated for many years. Owned by Edward Bradley Measell, the store sold many everyday items, everything from fresh fruit to spirits. A 1925 ad in the *Frederick Post* shows that Measell's participated in a Crisco promotion in which customers would receive a free cake pan and booklet of recipes with a purchase of the shortening.

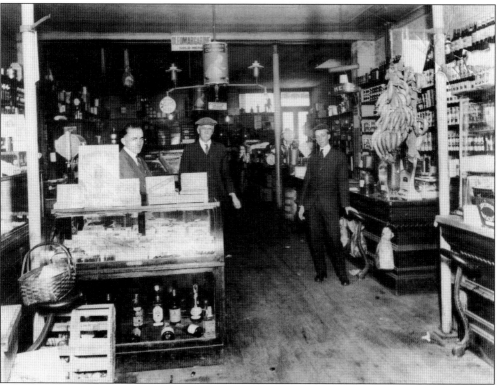

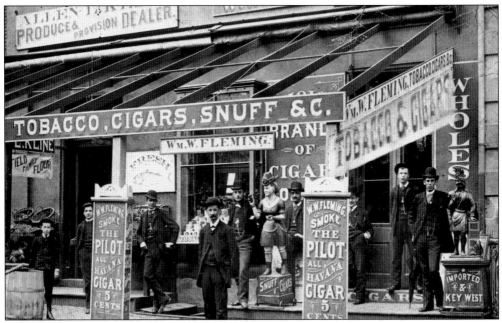

William W. Fleming's tobacco shop was located on West Patrick Street in Frederick next to the Frederick County National Bank. Later, the bank bought Fleming's to allow for expansion. Allen L. Kline Produce and Provision Dealer sold a variety of items next door. According to an ad in the 1895 *City Directory*, Kline sold "All kinds of country produce, provisions, fresh fish and oysters in season. Canned goods and pickles."

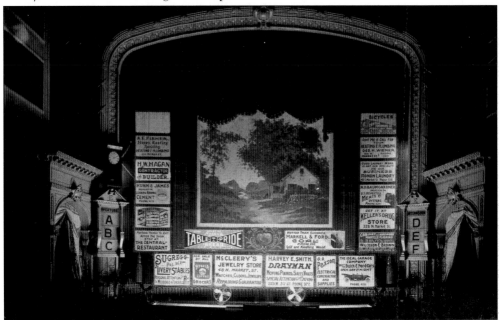

The advertisements in this c. 1920 image of the stage at the City Opera House in Frederick show one of the many ways businesses promoted themselves at the turn of the 20th century. Another popular marketing technique at the time was the use of advertising cards, which carried scenic, humorous, or otherwise interesting pictures and sayings to entice customers.

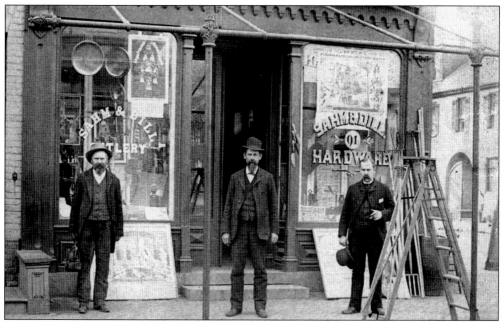

This *c.* 1895 photograph shows the Sahm and Dill Hardware and Cutlery store, located on the southwest corner of Market and West Second Streets in Frederick. In an 1896 edition of the *Frederick News*, Sahm and Dill advertised "Crawford bicycles: high grade wheels at $75 and; medium grade at $60."

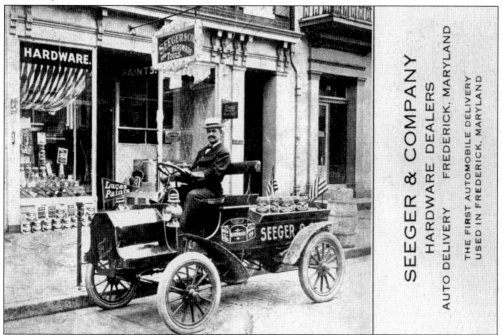

Seeger and Company Hardware must have been proud of the delivery services it offered as shown in this advertising card. Located on West Patrick Street in Frederick, they dealt in light and heavy hardware. According to the 1923 *City Directory*, Seeger and Company was the place "where you get what you like and like what you get."

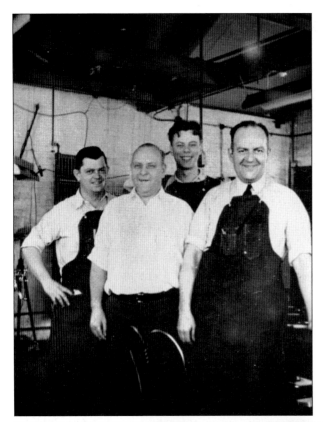

Founded in 1908 by Joseph and Osborne Price, Price Brothers Electric was incorporated in 1920. During World War II, the company produced remote-control radio transmitters and lifeline equipment, winning the Army-Navy "E" Award for excellence. Originally located on East Church Street in Frederick, the company built a plant near the fairgrounds in the 1950s. Shown are tool and die makers, from left to right, Joseph Wolf, Cecil Stine, unidentified, and Frank Miller, *c.* 1939.

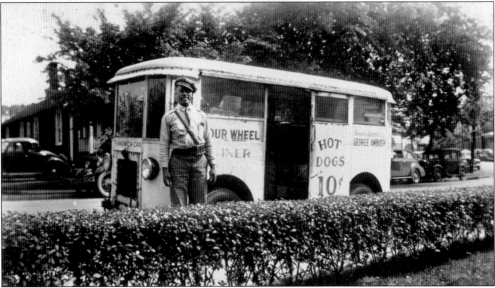

George Ambush operated a lunch wagon in the 1940s. Popular for its delicious sandwiches, Ambush's business also was known for its catchy slogan, "The six wheeled diner, where service is finer." Much of his clientele included employees of local Frederick companies like Price Electric and Frederick Iron & Steel, which would coordinate their lunch hours to accommodate the wagon's schedule.

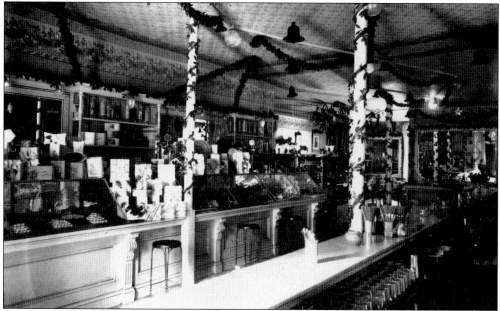

This photograph shows the interior of Sheeley's in Frederick, c. 1920s. Sheeley's was a popular confectioner and ice cream parlor on West Patrick Street. Notice the neatly stacked candies in the glass case at left and the soda glasses lined up behind the counter at right. The cases in the back held cakes and other treats.

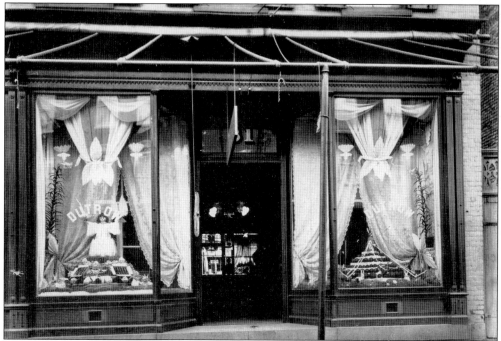

Located on North Market Street in Frederick, Dutrow's was a confectionery and soda fountain. Owned by Richard S.J. Dutrow, it provided Fredericktonians with a variety of tasty treats, including ice cream, ice cream sodas, college sundaes, ices, hot soda, taffies, and candies. Pictured here are Dutrow's display windows decorated for the Easter season.

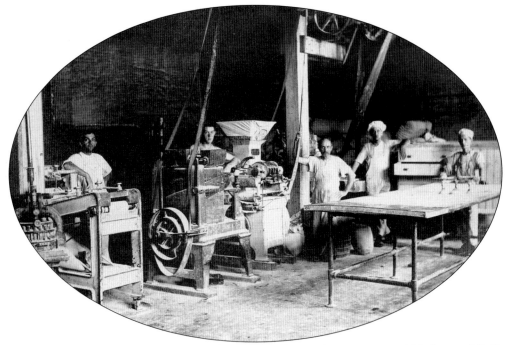

By 1919, Garber's Modern Bakery was located on the southwest corner of Market and Fifth Streets in Frederick, formerly the location of Nicolas Blumenauer's bakery. Garber's Bakery was established as Meier's in 1900 by August Meier, a German immigrant. A 1931 advertisement requested, "Ask for Garber's Bread—It's Different." The bakery later became Glade Valley-Garber before being purchased by a larger company in the 1950s.

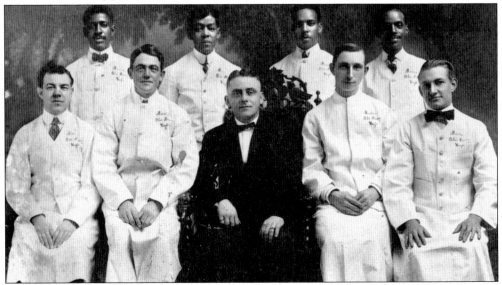

Pictured are employees of Bartie's Old Glory Café and most likely its proprietor, Millard Ernest Barthlow (seated at center). Listed in a 1915 Frederick *City Directory* as Barthlow's Café, the establishment was located on North Market Street, with Barthlow listed as "saloon keeper." He also was the owner of Bartie's Peanut Palace, known for its "good eats and good beer," on South Market Street in the 1930s and 1940s.

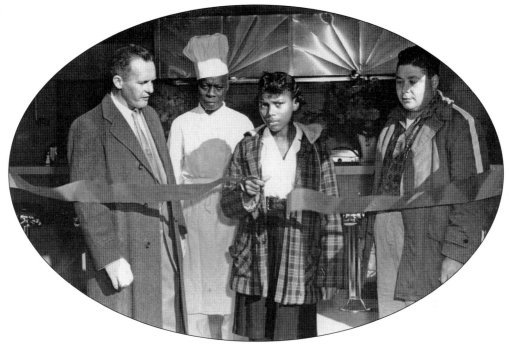

A ribbon-cutting is attended by (from left to right) Charles Ford, Jim Glover, Sandra West, and Roy Romsburg in Frederick in the 1950s. (Although photographer Frank Keefer recorded the "who" of the image for posterity, the "when" and, especially, the "where" are still in doubt. Let the Historical Society know if you can shed some more light on this image.)

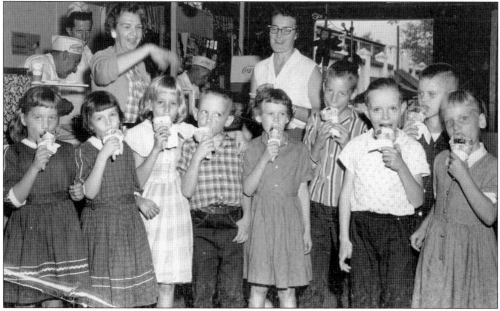

Elementary school students from the Maryland School for the Deaf enjoyed ice cream cones one warm day c. 1950s. Behind the children and their chaperones are three counter clerks wearing Nicodemus Ice Cream Company hats. The popular ice cream business was located on East Patrick Street in Frederick near Carroll Creek.

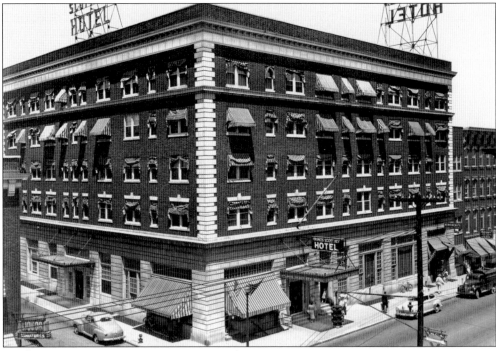

It seems tourism has always been an important part of Frederick County's economy. The Francis Scott Key Hotel was constructed in 1923 at the corner of West Patrick and Court Streets in Frederick on a site that had served as a tavern and hotel as far back as the late 1700s. Popular in its day, the hotel hit hard times and closed in the 1970s.

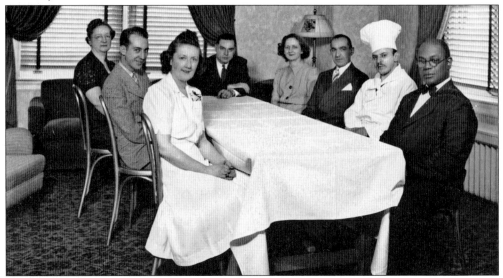

The Francis Scott Key Hotel's department heads posed for this photograph in 1941. Pictured are, from left to right, Mattye Montgomery, hostess in the coffee shop; J.R. Zimmerman, assistant manager; M.J. Nicodemus, housekeeper; J.A. Shires, manager; A.B. Carter, auditor; Orville F. Amick, office manager; Theodore Semler, chief steward; and Joseph Harvey, headwaiter. All had worked together since 1933 and represented a service record of 116 years at the time of this photograph.

Three

MOVING

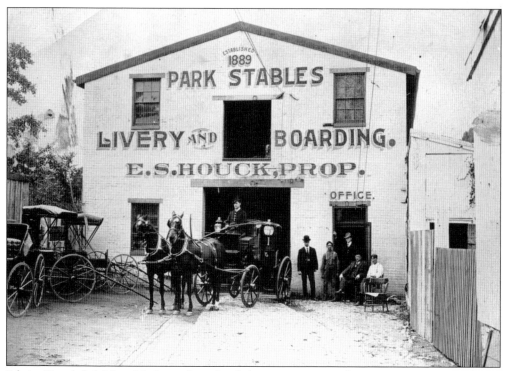

Edwin Houck left New Market, where his father was mayor and magistrate, to open a livery and boarding business on West Patrick Street in Frederick about 1890. In 1892, when Houck's was one of six such businesses in the city, his advertisement boasted "Special rates for Traveling People." Later, he sold rubber tires for his vehicles. By 1909, he had given up the business for other pursuits.

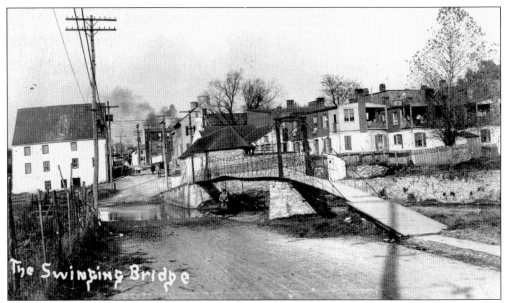

The Swinging Bridge

Until 1928, wagons and livestock traveling down Bentz Street in Frederick waded across Carroll Creek; pedestrians had the "Swinging Bridge." Built about 1875, the wooden-planked bridge was suspended by cables from iron supports. Eventually, the bridge was dismantled and replaced with a concrete bridge to serve automobile traffic. The Swinging Bridge found new life in 1930 when it was reconstructed as a foot bridge over Carroll Creek in Baker Park.

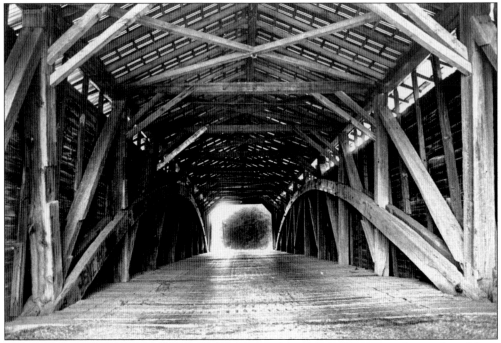

The interior of the Utica Mills Covered Bridge is featured in this image. Located on Utica Road between Lewistown and Utica, the bridge spans Fishing Creek. Originally built in 1834 to cross the Monocacy River on Devilbiss Road, the Utica Bridge was relocated to its current location in 1891.

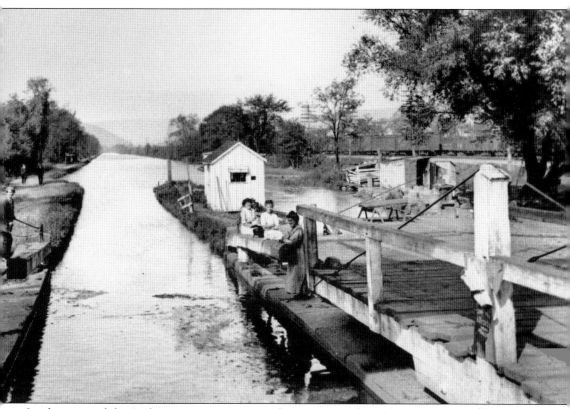

In this turn-of-the-20th-century image, several women sit along the Chesapeake & Ohio Canal at Brunswick while railroad cars of the Baltimore & Ohio Railroad rumble by in the background. Construction on the C&O Canal began with a ceremony at Little Falls on July 4, 1828. After financial difficulties and multiple delays, the approximately 185 miles of waterway was finally completed in 1850. Intended to provide transportation for goods by water from the Chesapeake Bay inland, the success of the canal was tentative from the beginning because of competition from the B&O Railroad. In 1831, the C&O and B&O experienced a standoff that halted construction of both enterprises at Point of Rocks. The resulting court battle over right-of-way proved an ominous omen for the canal. Damage from floods also contributed to the canal's difficulties, and, after hitting its peak in 1875, the canal saw a steady decline and discontinued service in 1924. The federal government purchased the canal in 1938, and the C&O Canal National Historical Park was created in 1971.

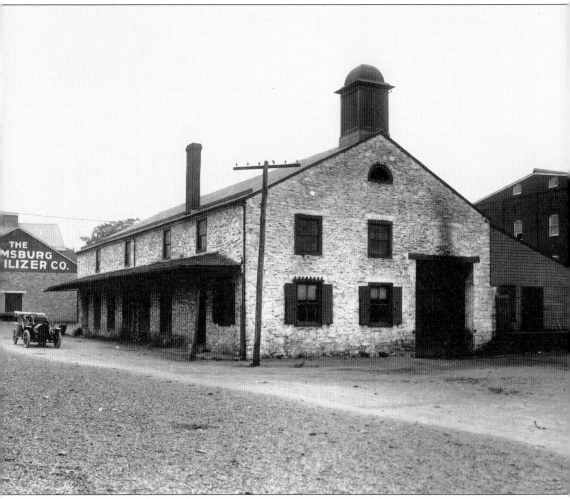

At one time touted to be the oldest railroad depot in the world, the Frederick B&O Railroad depot, located at Carroll and East All Saints Streets, opened on December 1, 1831, with the ceremonial arrival of the first train. The building was primarily used as a freight depot with minimal passenger amenities. It continued as a freight depot after a passenger station was constructed at South Market and East All Saints Streets in 1854. In 1911, shortly after this photograph was taken, the building was partially demolished in order to accommodate larger freight trains. The remaining structure was demolished in the 1930s and a frame building later was constructed on the site.

Mount Airy was first settled in the years surrounding the arrival of the B&O Railroad in the 1830s. In 1875, the B&O built the station shown here. The portion in the foreground, which served as a passenger waiting room, was added in 1882. The last passenger train passed the station in 1949, and in 1989, the station and surrounding property were sold by the Chessie railroad system to private owners.

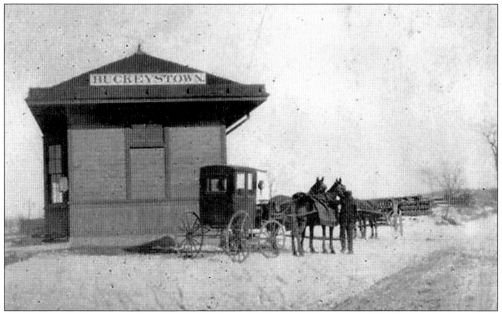

In this early-20th-century image, carriages at the B&O station in Buckeystown perhaps await arrivals on the next train. The station, located less than a mile from the village on Manor Woods Road, was Buckeystown's second. In the early 1900s, teenagers boarded the train at the station to travel to Frederick to attend high school there.

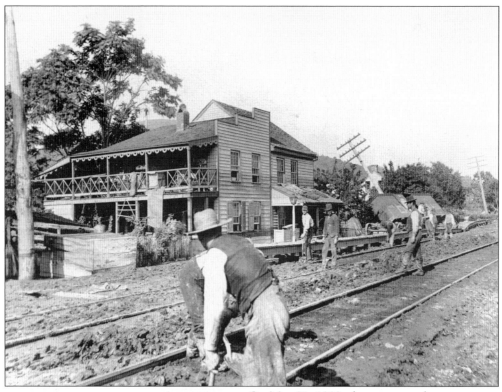

On May 31, 1889, the same weather system that caused the Johnstown Flood hit Frederick County. At Point of Rocks, the Potomac River swelled and almost completely covered the town with water. Buildings were submerged up to the second story; railroad cars were derailed and tracks damaged. In this image, workers clean debris from the tracks. In the following days, hundreds of people took trains to the town to view the damage.

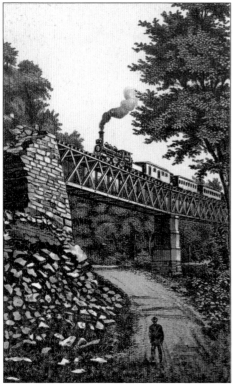

This image from *Western Maryland R.R Scenery*, a small picture book, shows a steam engine and cars traveling over the bridge above Mechanicstown, renamed Thurmont in 1894. Many in the town made their living through the railroad. Tragedy struck the community on June 17, 1905, when 26 men from Thurmont and the village of Catoctin employed by the Western Maryland Railroad were killed in a rail collision at Ransom, Maryland.

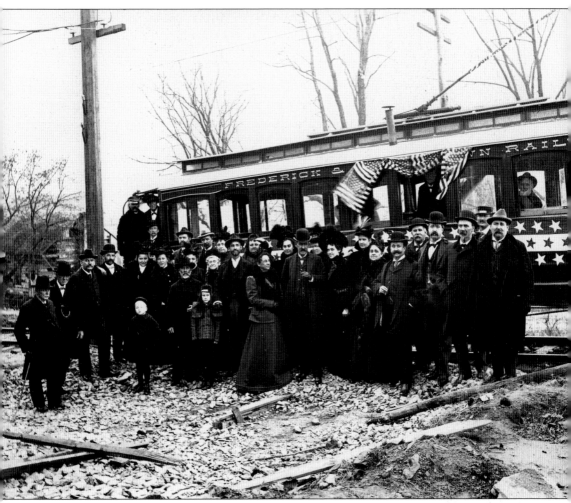

Adm. Winfield Scott Schley enjoyed a hero's welcome a few months after his July 3, 1898 victory in the Battle of Santiago during the Spanish-American War. Gathered here in Braddock Heights, following an excursion on one of the new trolley cars of the Frederick & Middletown Railway on November 19, 1898, were Admiral and Mrs. Schley (center) accompanied by friends and local dignitaries.

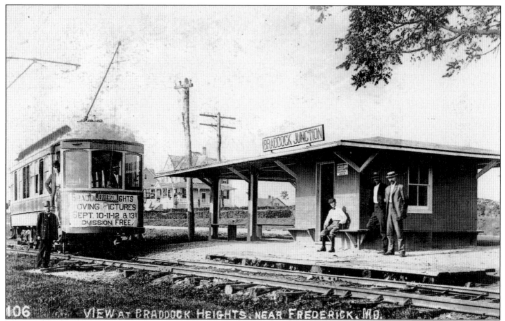

An amusement park and other attractions at Braddock Heights made it a popular destination for trolley passengers on the Frederick & Middletown Railway (F&M). At Braddock Junction, the branch line that ran through Braddock Heights and continued on to Jefferson divided from the main F&M line.

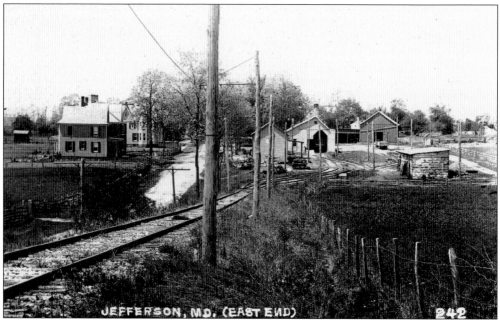

Tracks leading to the Jefferson station of the Frederick & Middletown Railway were part of the branch line that went from Braddock Junction south to Jefferson. Plans to extend the line to Brunswick never came to fruition.

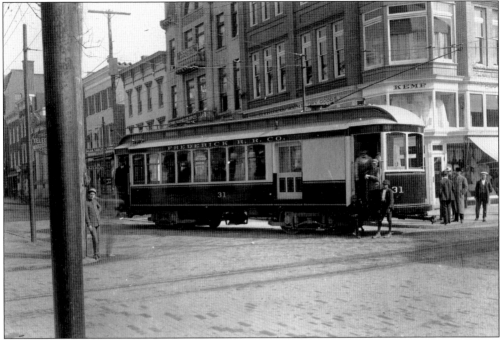

The Frederick Railroad Company's trolley number 31 paused at the "Square Corner" in downtown Frederick to capture this image in 1911. Kemp's Dry Goods store can be seen in the background.

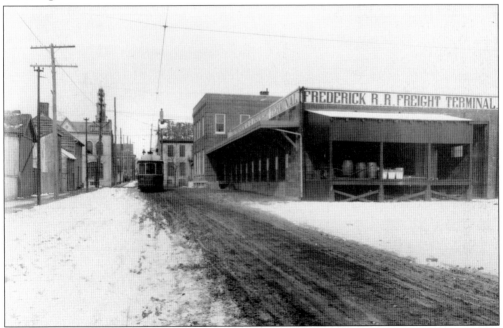

The Frederick Railroad Freight Terminal on South Carroll Street in Frederick went into operation in 1911. A passenger terminal occupied the front section of the building along East Patrick Street. The facility was used by the Potomac Edison Company after the railroad ceased operation. Today it houses the *Frederick News-Post*.

Workers installed rails for an extension of the Frederick & Middletown Railway in Myersville, c. 1898. Shares were sold to local citizens to finance the Myersville and Catoctin Railway, which moved passengers and freight through the town every two hours, 6:00 a.m. to 10:00 p.m. Although the last passenger trip occurred in 1938, and freight service ended several years after, Myersville's rail history is kept alive through an annual Trolley Festival.

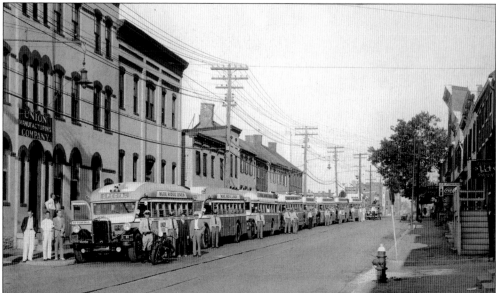

By the 1930s, railroad companies found themselves competing with bus lines for travelers. In this image, buses of the Blue Ridge Lines prepare to transport Union Manufacturing Company employees to an outing in 1936. Potomac Edison, which also operated the Frederick Railway, purchased the line in 1938. The bus service was headquartered in Frederick from its establishment in the 1920s until 1955, when it was purchased by Greyhound.

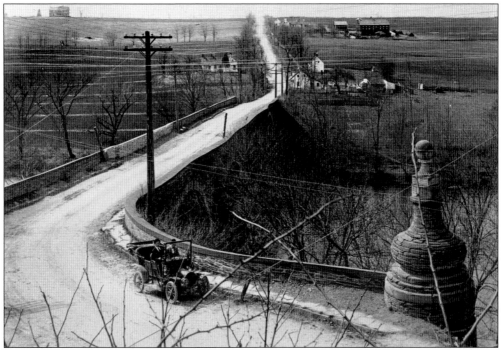

An early automobile crosses Jug Bridge over the Monocacy River in this c. 1910 image. The view looks west on the Baltimore Pike, part of the National Road. The road was a vital overland artery from the Colonial era. The original road follows parts of modern-day Routes 144, 40, and 70 in the county. In 2002, the National Road was designated an All-American Road by the U.S. Department of Transportation.

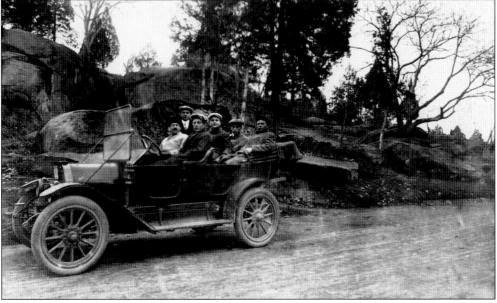

Pictured here is Lloyd C. Culler's new automobile on a trip to Gettysburg in 1919. From left to right are Floyd L. Culler, Claude F. Culler, Lloyd Culler, Paul L. Beard, and the "Trundle boys." By the 1920s, the automobile had pervaded the culture and day trips like this one were popular.

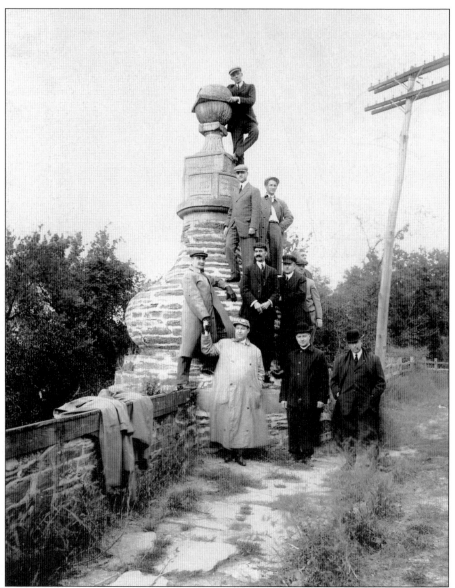

In 1900, 8,000 autos were registered in the United States; by 1920, the number was 9.2 million. By 1930, the city of Frederick boasted 15 automobile dealers and suppliers, 8 garages, 3 auto parts businesses, and 13 service and repair stations, among other related businesses. Similar businesses were peppered throughout the county. M.R. Etchison & Son advertised its "automobile funeral service." Indeed, the age of the automobile was firmly underway. The men photographed climbing on the Jug Bridge demijohn on the Baltimore Pike at Frederick likely were members of a local auto club. Auto clubs often were informal groups of individuals who gathered for day trips, to race, or to simply talk about and tinker with their automobiles. Long overcoats, driving caps, and goggles were not only a sporting look, but also practical in open or unheated vehicles. Even boots—in case one had to get out and push on muddy back roads—had function as well as style. The condition of the well-traveled road in the c. 1920 image provides evidence that a well-padded seat cushion also may have been more a necessity than accessory.

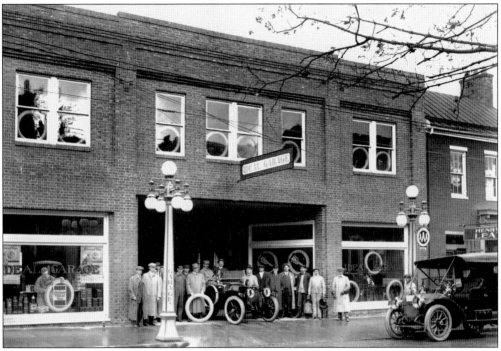

The Ideal Garage Company opened on Frederick's East Patrick Street in 1911 as one of the county's earliest automobile dealers. It sold Buicks and in the 1920s advertised 24-hour service and touted itself as the "largest and most complete garage in the state." In the 1950s, it added Opel and used cars, and in the 1970s, the company changed its name to Ideal Buick. The business moved to Urbana Pike in 1980.

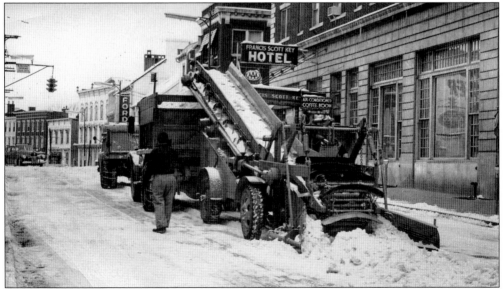

Maintaining roads and streets despite the weather has always been a challenging task. In this 1950s image, snow-removing equipment on Patrick Street in Frederick conveys snow up and into a truck to be hauled out of town. Ironically, the sign outside the Francis Scott Key Hotel touts its air-conditioned coffee shop.

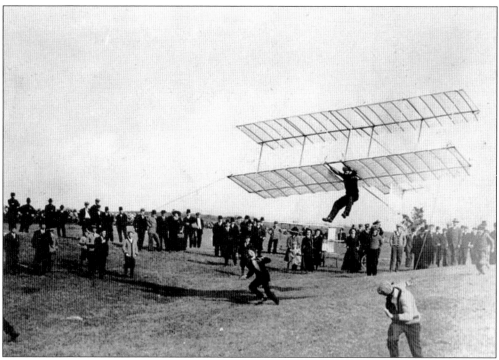

Many spectators watched as this early hang-glider was pulled skyward at an air show at the Frederick fairgrounds about 1912. It appears that this particular glider—basically, a giant kite—is being guided aloft by sweat and muscle; at other times an automobile was used.

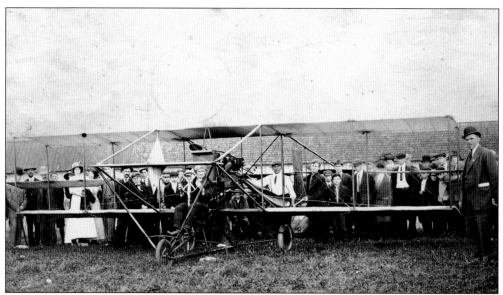

Shown here, aviator Lincoln Beachey piloted an early airplane at the Frederick fairgrounds on May 8, 1912. The first airplane to land in Frederick County did so on August 21, 1911. The plane flew from the Army Aviation School in College Park to Camp Ordway, now Fort Dietrick.

Four

SERVING THE COMMUNITY

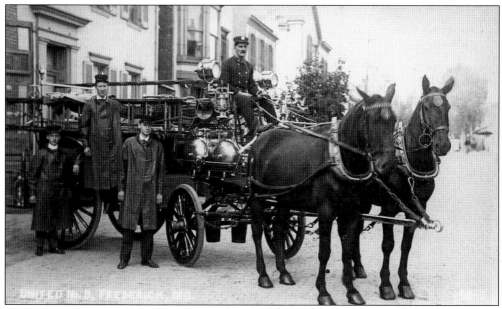

Horse-drawn fire trucks like this were used by the United Fire Company of Frederick until the early 1900s. The company's first pumper, affectionately known as "Lily of the Swamp," was purchased in 1878. "Lily" is now owned by the Smithsonian Institution and is on exhibit at the Fire Museum of Maryland. The somewhat later engine shown here sits in front of the South Market Street Firehouse.

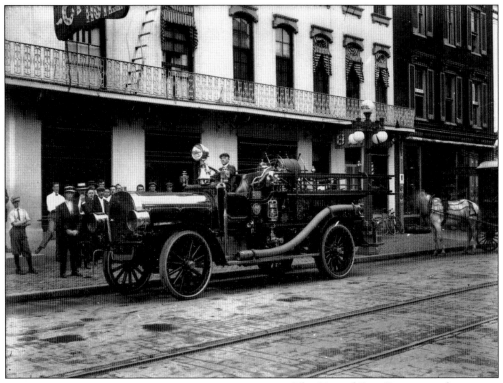

The United Fire Company of Frederick was organized on November 22, 1845, as the Mechanics Hose Company. They were later nicknamed "The Swamp" after they purchased land in the swampy area near Carroll Creek. The motor-driven engine pictured here in front of the City Hotel on West Patrick Street was purchased from the Waterous Company in 1912.

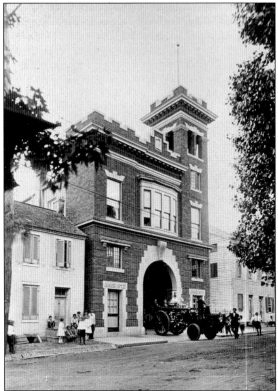

The Junior Fire Company No. 2 was incorporated in 1840. It was established two years earlier in Frederick by several young men, from whom it got its nickname, the "Young Men's Fire Company." The firehouse shown here was built in 1913. The equipment at the bay entrance is the Junior's Christie tractor, which was used with the company's 1908 LaFrance steam fire engine.

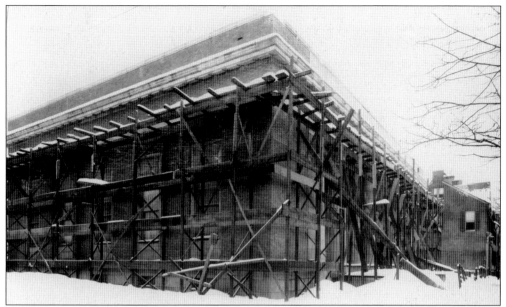

Progress on the construction of a new post office at the corner of East Patrick and Carroll Streets in Frederick is shown here during the winter of 1917–1918. The contract for the work was awarded to D.M. Andrews for $76,000. The cornerstone was laid on July 18, 1917. Despite protest from the City of Frederick, the building was demolished in 1983, following the completion of an adjacent postal facility.

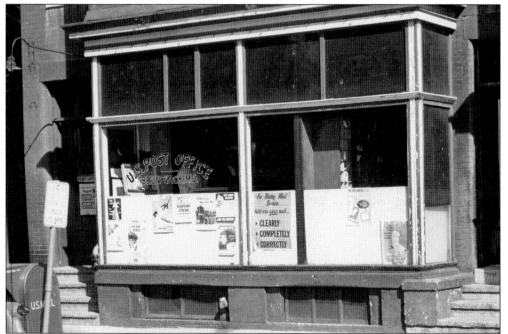

In 1832, the Barry Post Office was established in the town of Berlin. Both names were changed when the town of Brunswick incorporated in 1890. By 1958, when the U.S. Postal Service constructed a modern new facility in Brunswick, the location of the post office had changed ten times, including this storefront.

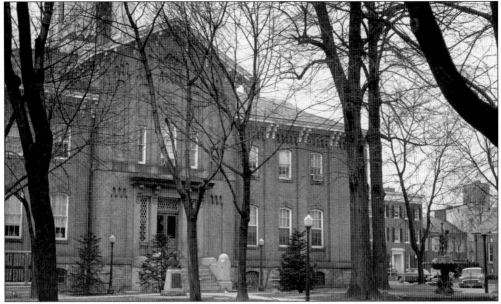

Construction of a county courthouse occurred in 1750–1756 on a three-acre parcel in Frederick purchased from Daniel Dulany. In 1785, a larger courthouse was built at Courthouse Square. That building burned in 1861—a fire set by Confederate sympathizers according to local Unionists—and was reconstructed the next year. Following the opening of a new courthouse nearby in 1982, the historic building underwent renovation and became Frederick's City Hall.

"Fort" Benner.

The jail, constructed on West South Street in Frederick in 1875–1876, was at least the third jail in the town's history. Cell doors, locks, and bars were cast by Calvin Page & Co. of Frederick. Alonzo Benner, a confectioner from Liberty District, served as sheriff in 1887–1888. The building provided living quarters for his family and cells for the prisoners. The building now houses Beacon House, a shelter for homeless men.

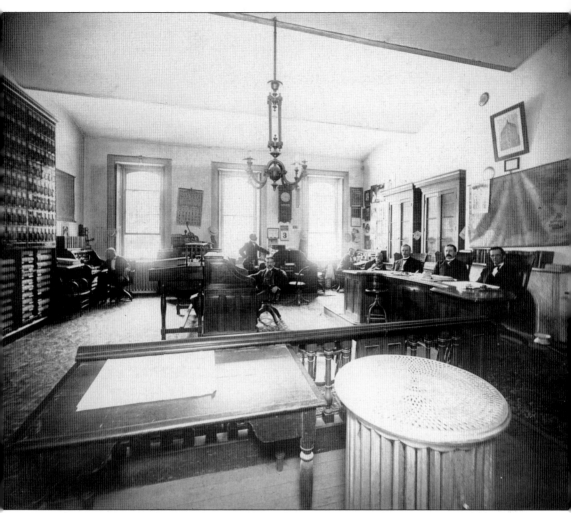

According to the calendars on the wall, these Frederick County Orphans' Court judges and clerks posed for this photograph in their courthouse office on July 3, 1905. The youngest judge was Russell E. Lighter, elected in 1899 and re-elected in 1903. The other judges, William H. Pearre and Jacob M. Birely, were elected in 1903. Maryland's county orphans' courts were established in 1777 by an act of the General Assembly to probate wills and deal with matters related to the settlement of estates, including inventories and appraisals. They also had jurisdiction over illegitimate or orphaned minor children to bind them to guardians or to masters as apprentices. The court's chief clerk served as the Register of Wills. Interesting details in the photograph include the gaslight fixture hanging from the ceiling, the fireplace and large map of the United States behind the judges, the spittoon near the bench, and the calendars and pictures on the walls above the clerks' desks.

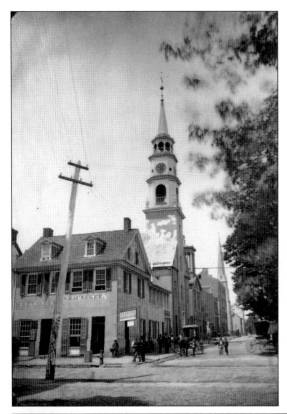

The *Examiner* newspaper offices were located at the southwest corner of Church and Market Streets, Frederick, when this image was captured *c.* 1883. The *Frederick Examiner* began publication in 1842, as a continuation of the *Frederick Political Examiner*. It was one of the dozens of newspapers published in the county during the 19th century. In 1854, diarist Jacob Engelbrecht noted that the *Examiner* had procured a Power Press and extras costing about $1,000.

These fellows just look like newspapermen, don't they? The employees of the *Frederick News-Post* are shown here in 1921, five years after *The Frederick Post* was acquired by *The News*. They are probably standing outside of the former plant and offices on North Court Street in Frederick. The *Frederick News-Post* has roots going back to October 15, 1883, when *The News* was first published. The locally owned daily is still published today.

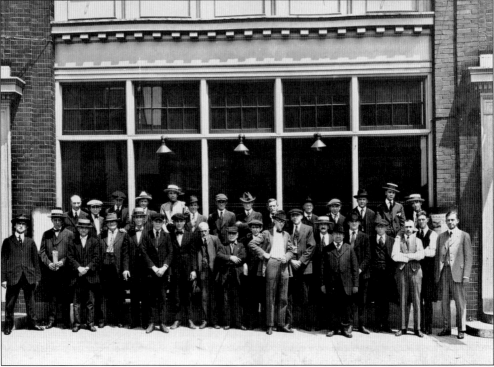

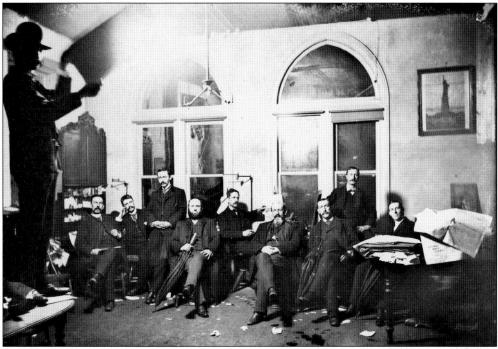

J. Davis Byerly photographed a group of businessmen observing Frederick's first known electric light illumination in the office of *The News* about 1888. From left to right are Dr. J.A. Williamson, Charles S. Howard, George Hane, Dr. P.D. Fahrney, William T. Delaplaine, Jacob B. Tyson, James A. Brown, unidentified, and Folger McKinsey. Dr. Williamson was the first to electrify his business, a drugstore next to the office of *The News*.

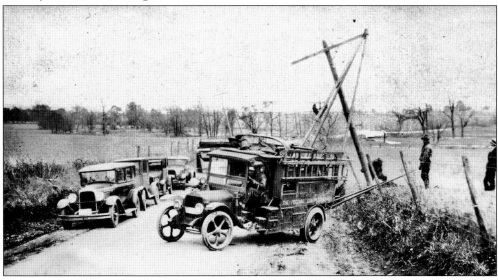

This Potomac Edison Company truck is on the scene of a damaged utility pole near Frederick in 1929. A tornado struck the area in May, killing several people, destroying homes and barns, and downing miles of power lines, leaving several towns without service. The Potomac Edison Company was formed from the merger of the Potomac Public Service Company, formerly the Frederick & Middletown Railway, and other regional power companies in 1923.

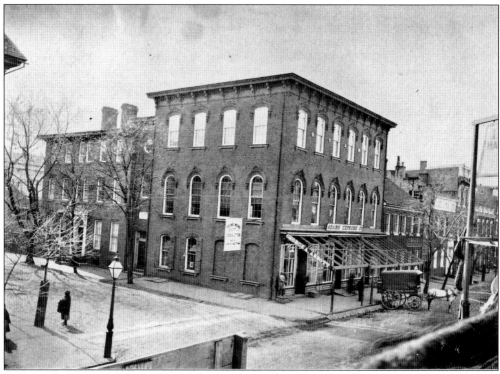

This view of Kemp Hall, on the southeast corner of Market and Church Streets in Frederick, shows a banner for the Young Men's Christian Association. The Frederick YMCA was reorganized in 1887, and a reception for William Bradley, its secretary general, was given at Kemp Hall by the Ladies Auxiliary. Weekly prayer meetings also were held there. Activity rooms were located next door on Church Street in the Reformed Church parsonage.

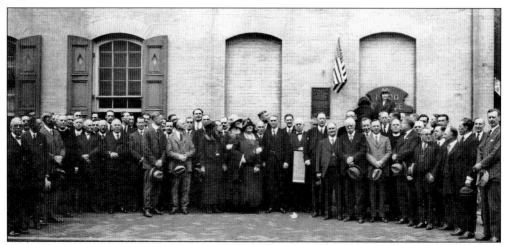

Members and guests of the Kiwanis Club posed beside Kemp Hall in 1924 after unveiling a plaque commemorating the Maryland Legislature's meeting held there in 1861. The Frederick Kiwanis Club was organized in 1922 and supported numerous civic causes, especially those helping underprivileged children. Kemp Hall still stands on the southeast corner of Church and Market Streets, though the facade displayed in this photograph has been altered.

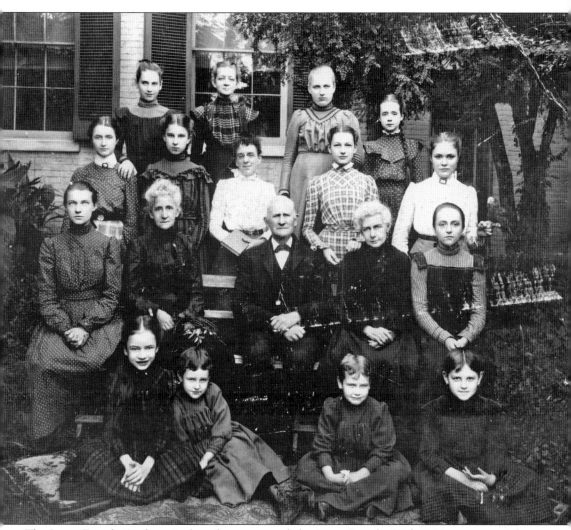

The Loats Female Orphan Asylum, later renamed the Loats Female Orphan Home, accepted its first girls in 1882. The orphanage was established after the death of John Loats, who left his Frederick home at 24 East Church Street and a sum of money for this purpose. A board made up of members of his family and the Evangelical Lutheran Church, where Loats attended, oversaw the orphanage. Between 1882 and 1956, when the Loats Home closed, it was home to over 100 girls. The two girls pictured on the ground at left are sisters Ida and Olivia Nuse. The woman seated directly behind them is Mrs. W.H. (Elizabeth) Hilleary, matron of the orphanage from 1893 to 1927. The Historical Society of Frederick County purchased the property in 1959 and now operates a museum and library in the home. Built-in lockers and other remnants of the home's previous use are still extant, and a room at the museum interprets this part of the building's history.

These children were photographed at the Order of Odd Fellows Home in Frederick soon after it opened in 1926. Dedicated to the organization's mission to serve children and the aged, the property once comprised 100 acres. When it opened, the facility included $100,000 in furnishings and equipment. Its working farm produced meat, poultry, eggs, and vegetables. Recently closed, the home served hundreds of members, widows, and orphans over the years.

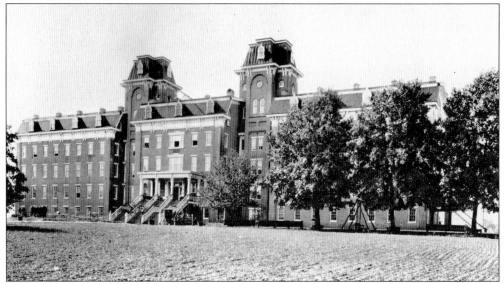

The Montevue Home, once located on Montevue Lane in Frederick, was built in 1870 to house the insane, sick, and needy of the county. In the 1960s, a major remodeling project was completed in which the top floor and porches were removed and the area that had once housed the homeless became a hospital. The building was demolished in 1987.

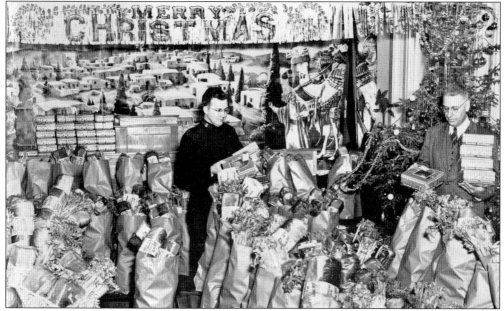

An unidentified Salvation Army officer and John W. Morgan stand surrounded by Christmas gift bags of groceries. Mr. Morgan was the district manager of the Potomac Edison Company and worked with the Frederick Salvation Army to collect food for the needy. Stalks of celery and loaves of Glade Valley Bakery bread are visible sticking out of many of the bags in this c. 1930s publicity photograph.

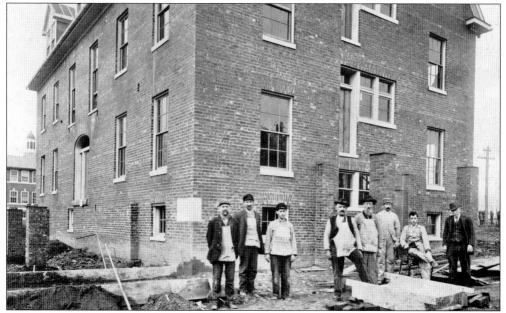

The cornerstone for the Georgianna Simmons Home for Nurses of the Frederick City Hospital was laid in 1912 during a Masonic ceremony. Georgianna Simmons had donated the building to the hospital for the facility, which was to house nursing students. Among other rooms, it contained 20 single-occupancy dormitories, two lounging rooms, a lecture hall, and a library. Red Frederick brick was used in the construction.

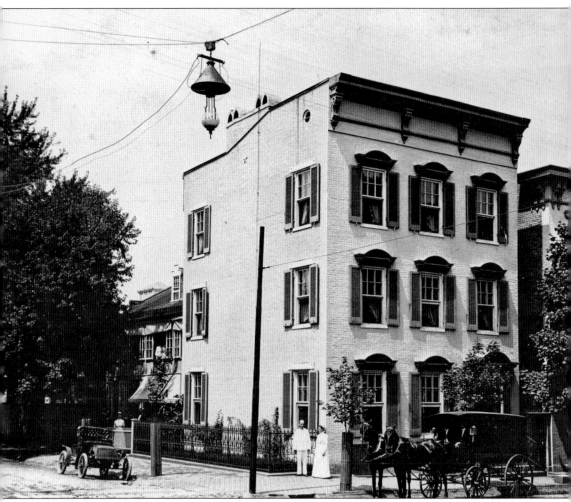

The Emergency Hospital on the northwest corner of South and South Market Streets in Frederick opened in November 1903. The September 30, 1904 edition of *The Citizen* reported that the facility offered separate public wards for male and female patients, as well as several private wards and rooms. An ambulance service "with all the latest accessories" could "be summoned at any hour to any locality." To ensure that medical help was available any hour, doctors who lived within the city rotated duty. The hospital was organized under the charter of the Frederick County Medical Society when local doctors decided they were unwilling to work at Frederick City Hospital, then under the direction of a female board of managers. Twenty-five members of the Medical Society staffed the Emergency Hospital, assisted by a female superintendent and several nurses. Doctors served as trustees, and many of their wives composed the Board of Patronesses. Differences between the Medical Society and the Frederick City Hospital were eventually settled, and the doctors agreed to treat patients at Frederick City Hospital. The Emergency Hospital closed in January 1907.

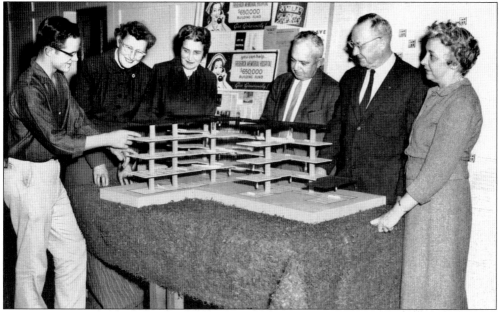

In 1959–1960, Frederick Memorial Hospital conducted a building fund campaign. Here plans are being shown to hospital directors, from left to right, unidentified; Corrie Douglas, president of the Women's Auxiliary; Matilda White, who organized the auxiliary in 1952 and served as its first president; W. Jarboe Grove; Rear Adm. Allen Quynn, U.S. Navy, retired, president of the Board of Trustees; and Blanche Michael, president of the Board of Managers.

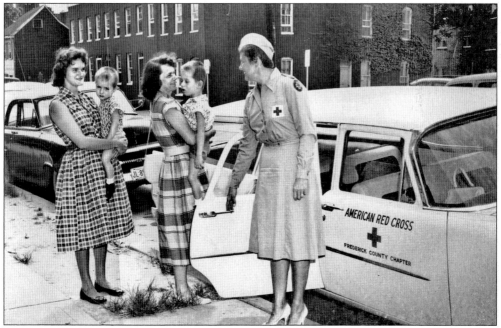

The Frederick County chapter of the Red Cross was founded on April 16, 1917. After World War II, the Red Cross shifted some of its responsibilities, and clinic duty and emergencies became the responsibilities of the women of the Motor Corps. Here, Mrs. Joseph Grossnickle (right) prepares to transport a family from Frederick to Johns Hopkins Hospital in Baltimore.

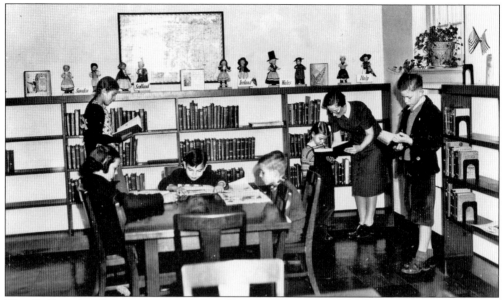

The C. Burr Artz Library first opened on Record Street in Frederick in 1938. The children's room, pictured here *c.* 1950s, was located in the basement of the building. The library was established through funds left to the city for this purpose by Catherine Thomas Artz, widow of Christian Burr Artz, for whom the library is named. Eventually, the library outgrew this building and moved to East Patrick Street in 1982.

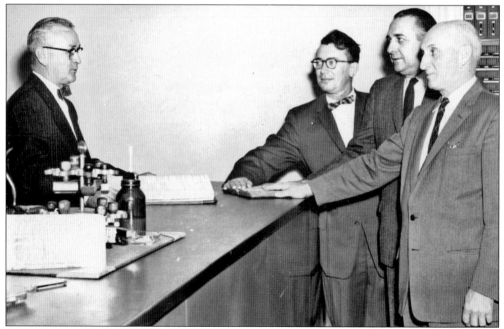

Ellis Wachter, clerk of the court, swore in newly elected county commissioners Delbert Null (president), Irving Renn, and Mehrl H. Ramsberg in 1958. It was Ramsberg's second term of office. At present, Frederick County still uses a commissioner form of government, which places legislative and executive authority in an at-large elected board of commissioners. Since the time of this photograph, the Board of Frederick County Commissioners has expanded to five.

Five

LEARNING

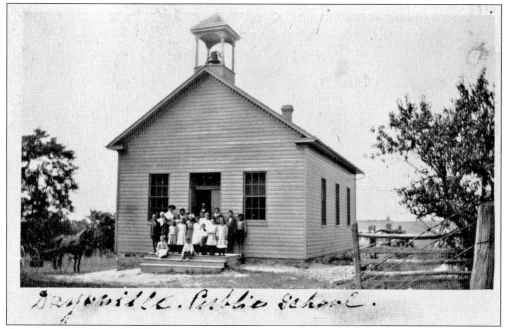

A group of students had their picture taken on the steps of the Daysville Public School c. 1910–1915. The school, also known as the Pine Tree School, was moved several hundred yards from its original site in 1894 to the location pictured here. Three Staley siblings—Elmira, Clara, and Grace—are among this group of students.

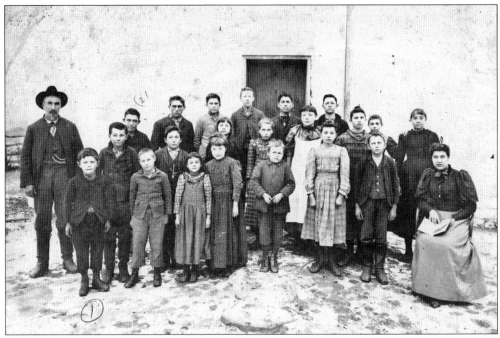

Three Ainsworth siblings joined their fellow students at the Johnsville School for this photograph taken about 1893. John E. Ainsworth stands at the left end of the front row. His sister, Bertha, is fourth from left in the same row, and his brother, Charles, is at the left end of the back row. The other students and the adults are unidentified.

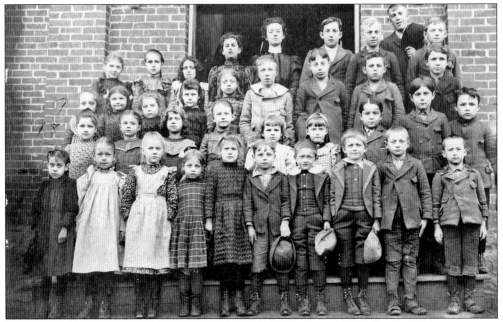

Woodsboro Elementary School students stood in front of their school about 1900 to have their photograph taken by Theo J. Myers. Their teacher, Miss Cora Shaw, stood at the center of the back row. At least one of the children, Clara Donsife—fourth from the left in the second row—later became a teacher.

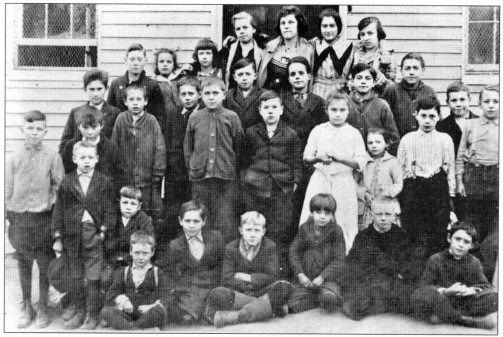

December 18, 1919, was school picture day for the seven grades of Bartonsville Public School. The teacher, Grace Burgee (Mrs. P.H. Beavers), stood second from left in the back row. She later said that 20 of her students were absent from the picture either because they were ill or because they were afraid of the camera.

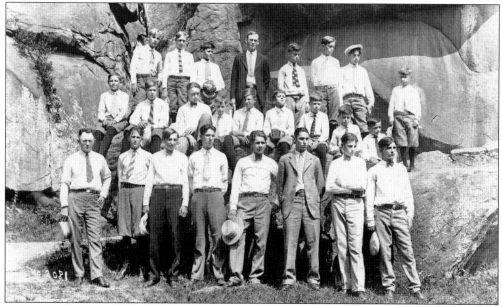

The Buckingham Industrial School was established in Buckeystown in 1898 by members of the Baker family to provide educational opportunities for poor boys whose home or financial situations hindered them from receiving a quality education. This c. 1929 image shows a group of Buckingham boys whose behavior the previous year had been good, earning them a field trip to Gettysburg, Pennsylvania.

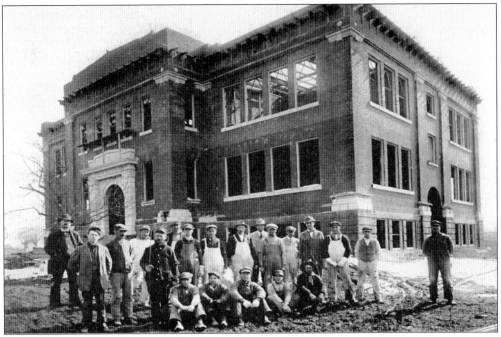

Workers gathered to have their photograph taken in front of Thurmont High School while it was under construction in 1915. The new high school replaced the original public high school, which was constructed in 1896 and had been damaged by a severe storm in 1914. A west wing was added to Thurmont High School in 1928. It now houses the Thurmont Middle School on East Main Street.

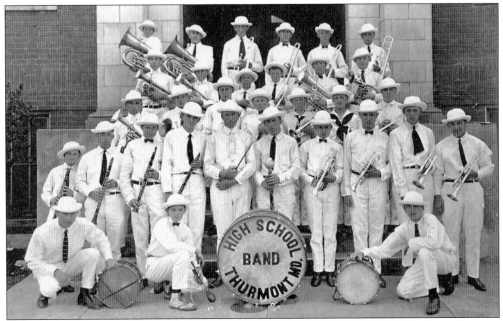

The musicians of the Thurmont High School band posed in front of their high school building about 1920. Thurmont's band participated in the School Exhibition at the Frederick County Fair and marched in various parades in Frederick.

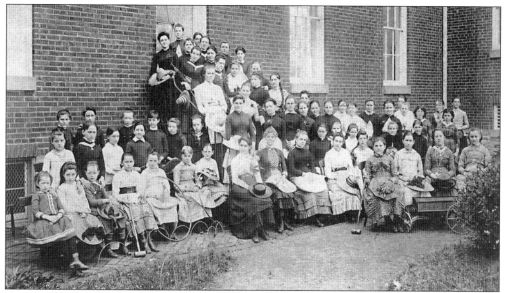

St. Joseph's Academy and Free School in Emmitsburg was established in 1810 by Mother Elizabeth Ann Seton and the Sisters of Charity of Saint Joseph's. It was the first free Catholic school for girls in the nation. Several students in this *c.* 1890s group display items that suggest activities that may have offered diversions from their academic endeavors. The school developed in 1902 into St. Joseph's College, which continued until 1973.

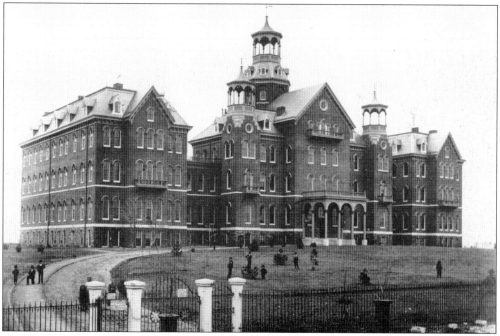

The Main Building of the Maryland School for the Deaf stood for nearly 100 years on South Market Street in Frederick. Construction began in 1870. When the state failed to appropriate funds for the ongoing construction in 1872, Baltimore industrialist and philanthropist Enoch Pratt loaned money to the state, and construction continued. He later served as president of the Board of Visitors for the school.

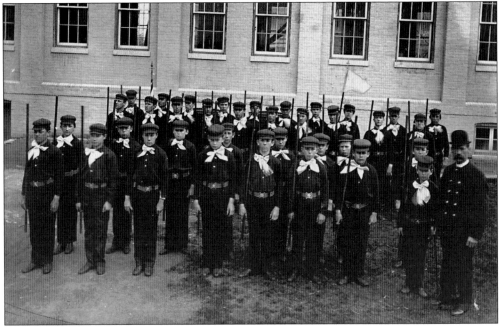

Uniformed male students at the Maryland School for the Deaf stand in formation beside the Reigel Industrial Building on the campus sometime between 1919—when infantry drilling commenced—and 1925, when the building was razed. The boys received military exercise training, including exercises with sticks carved to resemble rifles.

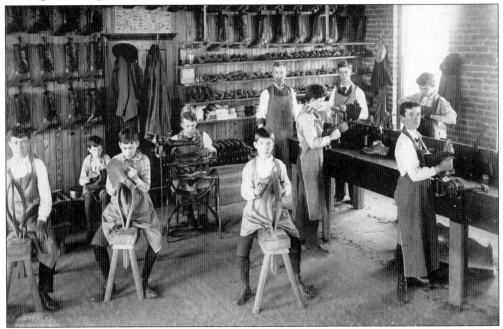

To prepare students to make a living as adults, the Maryland School for the Deaf offered training in several trades. Near the end of the 19th century, these boys and young men learned shoemaking. Most of the boys worked with hand tools, but the fourth student from the left used a sewing machine. On the wall is a picture illustrating various kinds of boots and shoes.

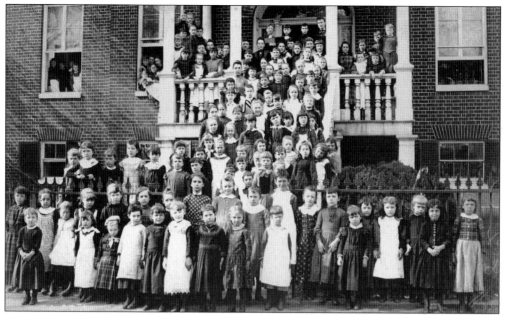

Elementary students posed about 1888 in front of the East Church Street School, a former private residence constructed in 1815. The last family to own the house, the McGills, sold it to the county in 1877, when it became an elementary school for girls. After being declared unsafe and unsanitary, it was razed in 1900 to make room for constructing a new Female High School building.

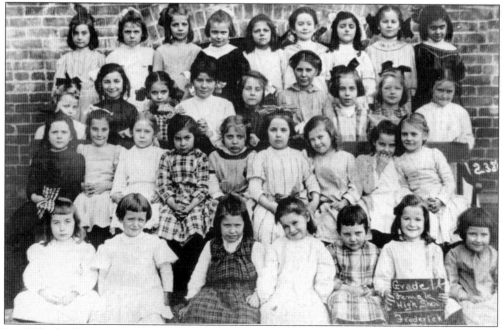

In 1910, the first-grade class of the Frederick Female High School posed for their class picture in front of the school on East Church Street in Frederick. The c. 1900 building accommodated the elementary grades on the first floor and the high school grades on the second floor. The building now houses offices for the Frederick County Board of Education.

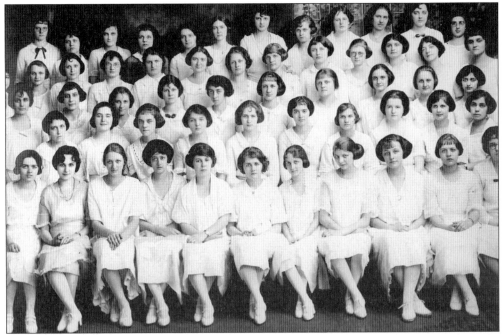

The Girls' High School (formerly Female High School) Class of 1922, nicknamed the "Baby Class," was the last class to graduate from the school on East Church Street. The Frederick Boys' High School on Elm Street then became coeducational.

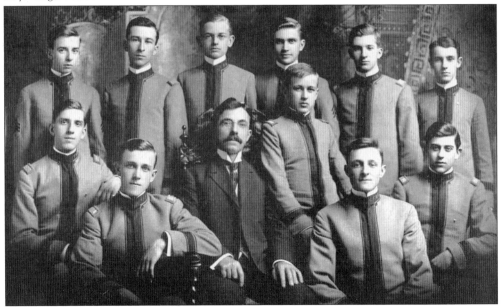

The Frederick Boys' High School Class of 1910 clustered around their principal, Prof. Amon Burgee, in this photograph by the Etchison Studio of Frederick. They are, from left to right, (front row) Lewis Henry Knock and George Stanislaus Rodock; (middle row) Garrett Schreiner DeGrange Jr., Professor Burgee, John E. Schell Jr., and Earlston Lilburn Hargett; (back row) Harold Kuhlman Moberly, Garl Daniel Sunday, Edward Schley Delaplaine, George Roy Hess, William Scholl Hersperger, and William Lawrence Schaefer.

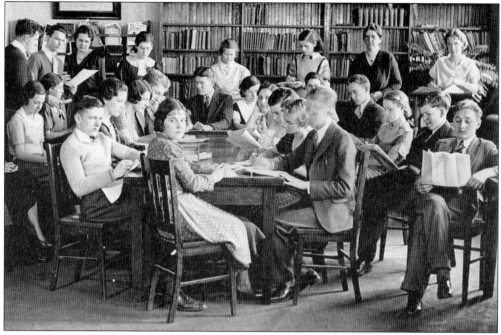

Students of Mary Julius Shuff study in the library of Frederick High School, then located on Elm Street. Miss Shuff, who had taught at the Girls' High School, moved to Frederick High when it became a coeducational school in 1922. Miss Shuff, second from the right in the back of this image, was active in various civic and cultural groups and continued teaching into the 1940s.

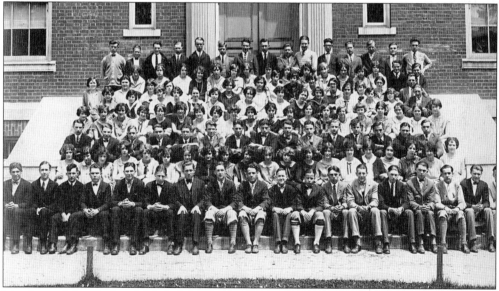

Members of the Frederick High School Class of 1925 posed on the steps of their school on Elm Street. The 133 students chose blue and gray as class colors. Fifty years after graduation, students reminisced about the girls' bobbed hair and low-waisted dresses and about the boys' slicked-down hair. Of the 54 boys in the class, 17 served in the United States military during World War II.

The Frederick Academy of the Visitation faces East Second Street in Frederick. This c. 1915 view from the southeast corner of the garden includes the school, the chapel with its bell cupola, and the monastery buildings. Beyond the school buildings is the spire of St. John the Evangelist Roman Catholic Church. The academy, a girls' school founded in 1846 by 11 Sisters of the Visitation, serves both day and boarding students.

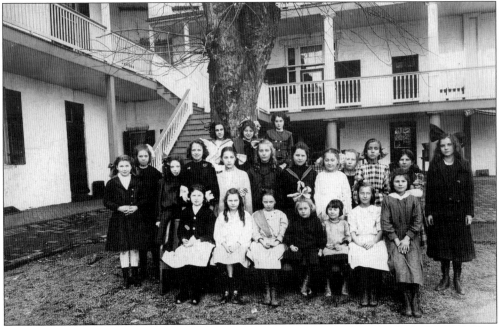

Students of the Academy of the Visitation in Frederick were photographed about 1915 in the courtyard of the academy. A half century earlier, 60 students endured the Civil War years within the cloistered walls, while the more public parts of the school were occupied as hospital facilities for sick and wounded soldiers. These students posed where recuperating men once rested.

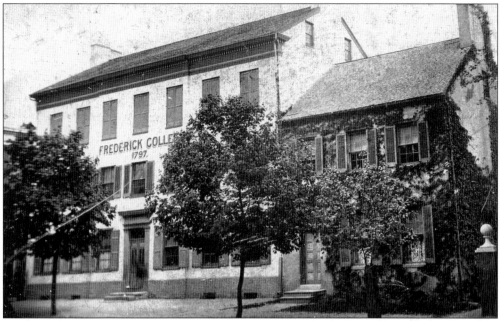

Frederick College, or Academy as it was known, was chartered as a preparatory and boarding school for boys. It opened October 2, 1797, with Rev. Samuel Knox as principal and teacher. This school building, shown c. 1900, was enlarged to a full three stories in the 19th century and stood at Record and Council Streets in Frederick until the 1930s.

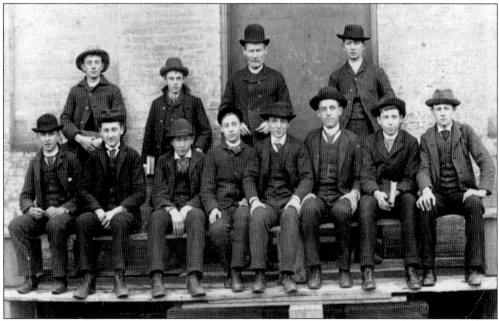

Frederick College students of 1889 posed in front of the school. They are, from left to right, (seated) H.E. Ebert, C. Kemp, D. Steiner, W. Saumser, W. Benner, W. Dansberger, C. Byerly, and Tom Turner; (standing) A.T. Webster, W. Zimmerman, teacher E.C. Shepherd, and Charles Groff. Graduates furthered their education by reading law or attending institutions of higher learning.

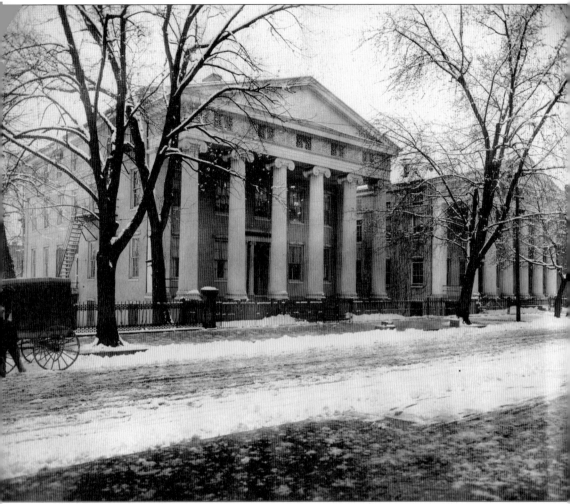

Winchester Hall on East Church Street in Frederick, shown here about 1909, was named for Hiram Winchester, a Connecticut-born teacher who opened the Frederick Female Seminary in the late 1830s. The east wing was constructed in 1843. The west wing was added in 1857 to accommodate the growing enrollment and during the Civil War served as a military hospital. In 1893, the building was leased to the Potomac Synod of the Reformed Church as the site for their female college, the Woman's College of Maryland. It received its charter in 1897 and conferred the bachelor of arts degree on its first graduating class of 14 students in 1898. As the college transitioned to its new location under its new name, Hood College, Winchester Hall's function changed. Between 1915 and 1920, it housed Hood College's Preparatory Department, and from 1920 to 1930, it served as a student dormitory. Today, Winchester Hall contains Frederick County government offices.

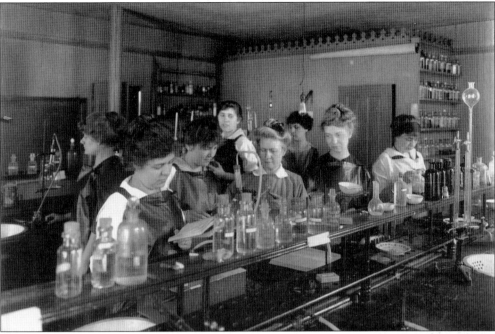

Several chemistry students at Frederick Woman's College, then located on East Church Street in Frederick, worked in a well-equipped laboratory. In this early 1900s image, they work with their instructor, surrounded by glass bottles of chemicals and other paraphernalia. The college's tradition continues on the Hood College campus on Rosemont Avenue, where science students enjoy a new and well-equipped science hall.

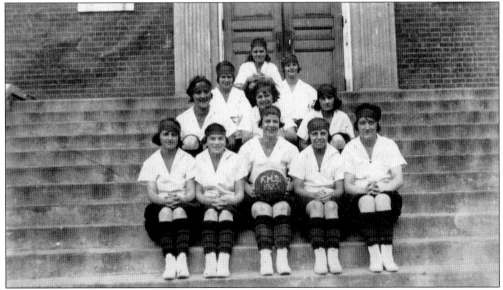

School athletics have a long history in Frederick County. Eleven members of the Frederick High School girls' fieldball team were photographed on the steps of Frederick High School in 1923, within a year of the school's becoming a coeducational facility. Their physical education teacher and coach was Betty Boyle. Fieldball was similar to soccer, except that the ball was thrown instead of kicked.

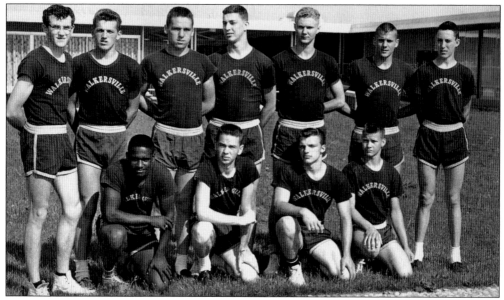

This group of Walkersville High School athletes qualified for the Maryland State Track Meet in the early 1960s. The athletes competed in several events, including 440- and 880-yard relays, discus and shotput, broad jump, and high jump. They are, from left to right, (kneeling) Bob Smith, Bob Zimmerman, Gene Beecher, and Leo Duncan; (standing) Lee Demaris, Bob Stull, Ron Dougherty, Ron Linton, Gary Beard, Sam Smith, and Ed Trout.

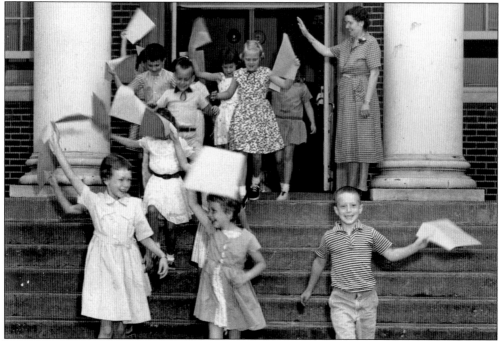

Miss Smith, principal of Parkway Elementary School, waves goodbye as students leave the school one day about 1960. The staged photograph was intended to simulate the last day of school. The school off Carroll Parkway in Frederick opened about 1930. Its first class of 50 seventh graders graduated in 1931. The building still serves elementary students in the city.

Six

WORSHIPPING

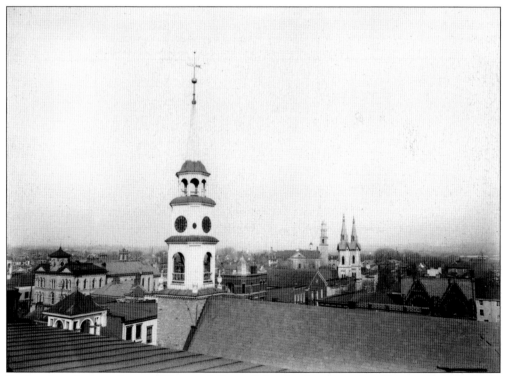

Frederick is known for its "Clustered Spires." In the foreground is Trinity Chapel of the Evangelical Reformed Church. The spire was once damaged by local fire companies who used it to test their hoses. The double spires in the skyline are of the Evangelical Lutheran Church; the lone spire behind belongs to St. John the Evangelist Roman Catholic Church.

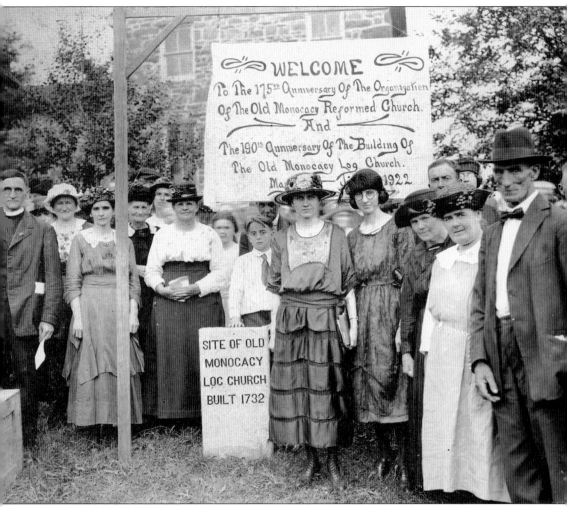

A marker was dedicated on June 4, 1922, at the site of the Old Monocacy Log Church on a knoll near the road from Creagerstown to Woodsboro. It was in celebration of the anniversaries of the church's construction and organization. Built in 1732, Old Monocacy was said to be the first church in Western Maryland. The Log Church was used as a house of worship until 1762, when another was constructed in Creagerstown. The older church was eventually ravaged by time and the weather, and its exact location lost. Although the Reverend Dr. P.E. Heimer, pastor of the Creagerstown Church for 19 years and seen at far left in the photograph, gathered evidence in support of this site, there is still controversy regarding the church's original location. Others pictured are Mrs. Floyd Wetzel, Mrs. C.V. Jackson, Mrs. Russell Hockinsmith, Mrs. George Bartgis, Mrs. Leroy Rhodes, Mrs. William Devilbiss, Dora Devilbiss, Charles Devilbiss, George Eichelberger Sr., Mrs. May Seiss Kase, Mrs. Mable Long Whitmore, Mrs. Clinton Stull, Mrs. John Speak, John Speak, Roger Geisbert, Mrs. William Troxell, and John B. Pittinger.

Property for the building of Our Lady of Mt. Carmel Church in Thurmont was purchased in 1857. Construction began that year using stone from the Catoctin Mountains. Cyrus Maser was the builder, assisted by Daniel Eigenbrode and others. An estimated 3,000 people attended the dedication services on June 5, 1859. The Reverend John H. Hickey Jr., attached to Mount St. Mary's College, was assigned to pastor the church.

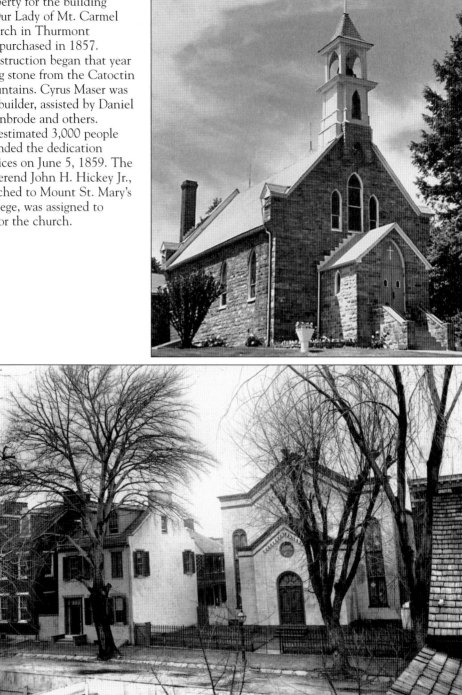

The Presbyterian Church in Frederick was officially organized in 1780, though the congregation held services as early as 1757. Pictured on this spot on West Second Street is the church's second building, which was completed in 1825 and dedicated two years later. The manse, pictured to the left of the church, was constructed during the pastorate of Rev. John Miller in 1848.

Rev. Osborne Ingle assumed the pastorate of All Saints' Episcopal Parish in Frederick in 1866. Tragically, Reverend Ingle lost a young daughter in 1881, and in January 1882, five of his children succumbed to diphtheria within a two-week period. His wife and young son died the next year. Reverend Ingle's daughter, known as Miss Mary, cared for and assisted him in his church labors until his death in 1909.

The c. 1896 photograph shows the All Saints' Episcopal Parish's second building on this site in Frederick. It was consecrated as their house of worship in 1814. After a new church was built between 1854 and 1856, this building became the parish hall and was used for educational and social purposes. During the Civil War, both buildings were used as hospitals for wounded soldiers.

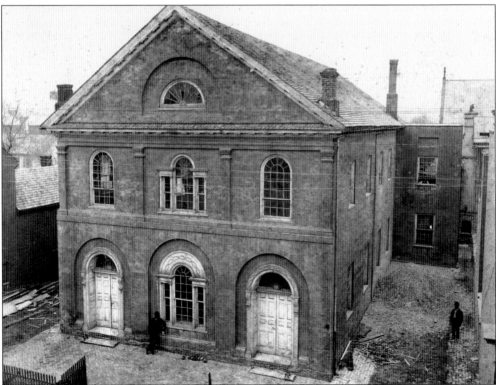

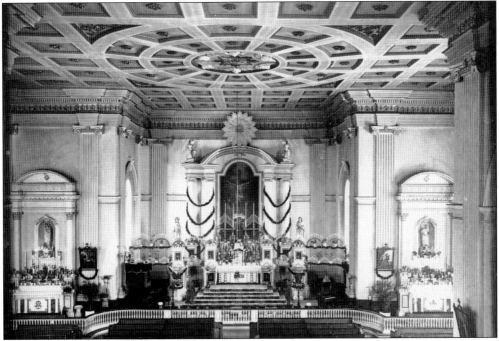

St. John the Evangelist Roman Catholic Church on East Second Street in Frederick was decorated to celebrate its Golden Jubilee in April 1887. Designed by local architect John Tehan and constructed under the leadership of Father John McElroy, St. John's was the nation's largest parish church when it was consecrated. The building, with its 50-foot high ceilings and ornate interior, was the first major Catholic church consecrated in the eastern United States.

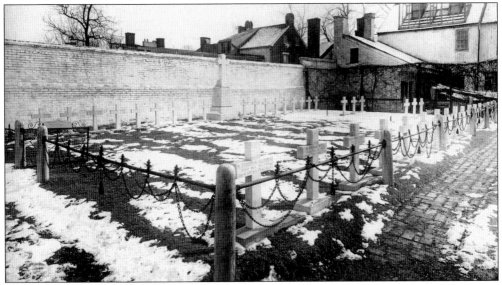

Nestled in a quiet corner of the grounds of Frederick's Academy of the Visitation and the Sisters of the Visitation on East Second Street is the cemetery where the remains of many Visitation Sisters rest. Simple crosses mark the sisters' graves. The fence previously surrounded the Jesuit Novitiate's cemetery. It was donated to the sisters for their cemetery by the Novitiate when it left Frederick in 1902.

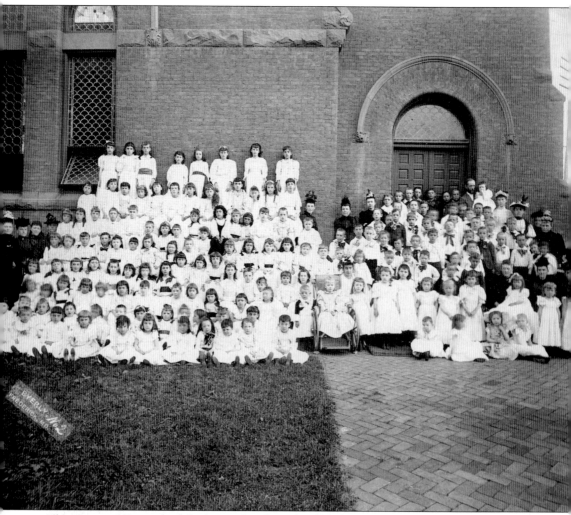

This group of Evangelical Lutheran Sunday school children and adults stood in front of the Schaeffer Center for Education and Service in Frederick, c. 1891. In 1890, in order to expand educational facilities, the new Sunday School Chapel on East Second Street was built and dedicated the following September. The center was named in honor of Rev. Dr. David F. Schaeffer (1787–1837), who served the Evangelical Lutheran Church as pastor for 28 years. He is credited with founding in 1820 the Sunday school program at the church. In 1912, a large room was added to the north end of the building and a wing was added to the east; a west wing was added in 1925. The Schaeffer Center still houses the Sunday school as well as classrooms for the Evangelical Lutheran Church's Wee Folk School.

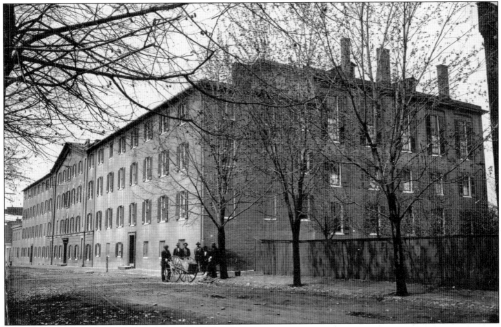

The Jesuit Novitiate stood on the north side of East Second Street in Frederick opposite St. John the Evangelist Roman Catholic Church. The Novitiate building stretched from Chapel Alley on the east some 250 feet toward Market Street on the west. The property also reached north to Third Street. When the Novitiate moved to New York in 1902, the building was razed and the property divided and sold as building lots.

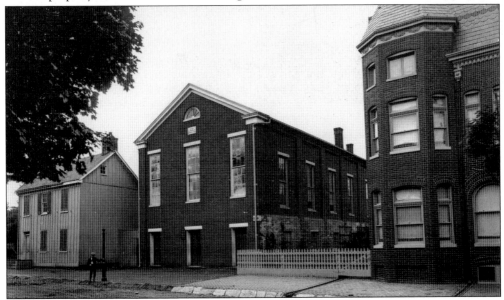

Quinn Chapel A.M.E. church began as the Bethel Congregation and first met in a shop adjacent to the structure shown in this early-20th-century image. Quinn Chapel was constructed on Third Street in Frederick in 1835 and named in honor of Bishop William Paul Quinn, fourth bishop of the African Methodist Episcopal Church. The board and batten-sided house beside the church served as the parsonage.

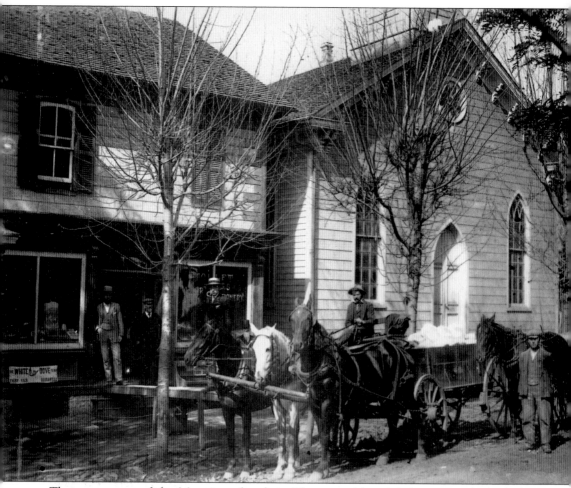

The cornerstone of the Moravian church in Thurmont (then Mechanicstown) was laid on July 10, 1874. Established by the Graceham Moravian Congregation, it was built for $2,400, including furnishings, many of which were donated by friends in Baltimore. The building was dedicated on December 6, 1874, with the 300-seat-capacity building filled to overflowing. Services were held in the building until 1918, when the remaining membership was transferred to Graceham Church. The building sat vacant until 1926 when it was sold to D.S. Weybright, who remodeled it for use as a store. Later, the building housed Ho-Mar-Way Dairy, the first pasteurized dairy in the area. In 1967, the building was again remodeled for use as a youth center known as Teentown. It now serves the community as the Thurmont Public Library.

Seven

CELEBRATING, COMMEMORATING, AND RECREATING

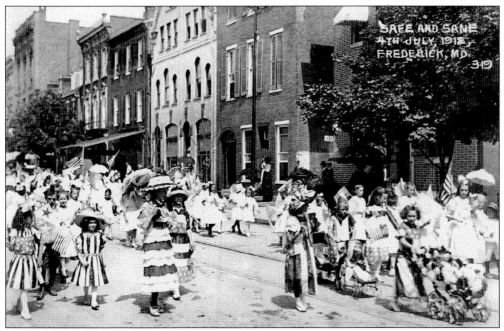

Little girls and boys, dressed in their patriotic finest, parade down Patrick Street in Frederick on July 4, 1912, to mark their "Safe and Sane" celebration of our nation's independence. The nationwide "Safe and Sane" movement started in 1908 in response to the increasing number of injuries and deaths related to the careless discharging of firearms and explosives on the Fourth of July.

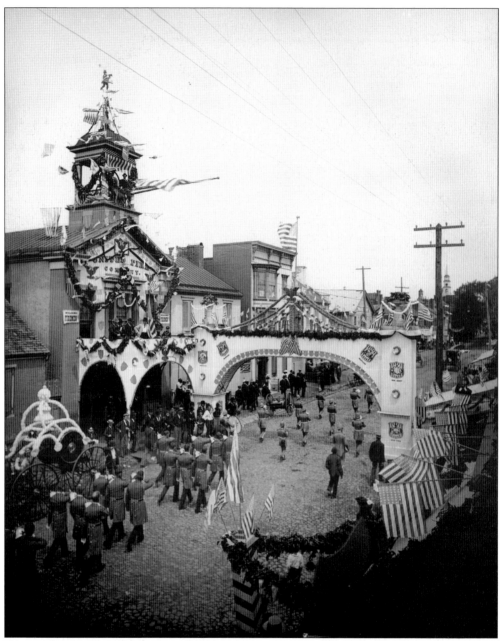

Firemen marched past the United Fire Company on South Market Street in Frederick as part of the first convention of the Maryland State Firemen's Association (MSFA) on June 7–8, 1893. The association was formed earlier in the year with significant representation from Frederick County's volunteer fire companies. Fredericktonian J. Roger McSherry was elected the first president of the association and presided over activities at the convention. The MFSA convention returned to Frederick a decade later. Parades, arches, and elaborately decorated fire houses were important parts of these early statewide conventions.

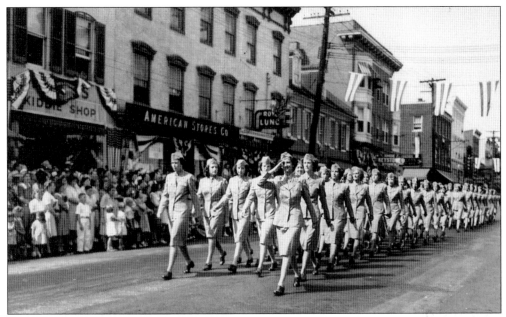

The end of World War II, just a month before Frederick was to celebrate its bicentennial on September 3, 1945, turned the city's planned founders' parade into a victory celebration. About 3,500 civilians and service men and women participated in the parade for over 30,000 onlookers from throughout the county. None were dressed any snappier or inspired more patriotic pride than these members of the Women's Army Corps.

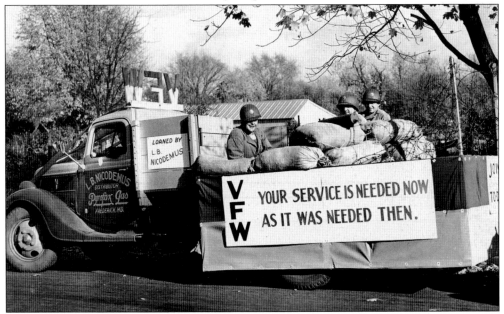

Lester B. Nicodemus's truck was relieved from hauling appliances from his North Market Street, Frederick store to customers' homes in order to participate in a post–World War II parade. Members of the Veterans of Foreign Wars hoped their float would entice comrades to join the growing service organization. The men wore helmets emblazoned with the emblem of the U.S. Army's 29th Division, many members of which came from Frederick County.

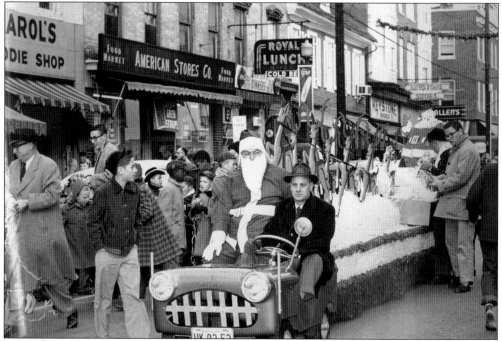

Santa Claus, a.k.a. Ed Winpigler, is chauffeured down North Market Street between Second and Church Streets in Frederick by Joseph F. Rhoderick in 1956. The Christmas parade was sponsored by the Chamber of Commerce. Carroll Hendrickson Jr., owner of Hendrickson's Department Store, and Sam Maples of Kemp's Department Store prepared the float pulled by Santa's miniature car.

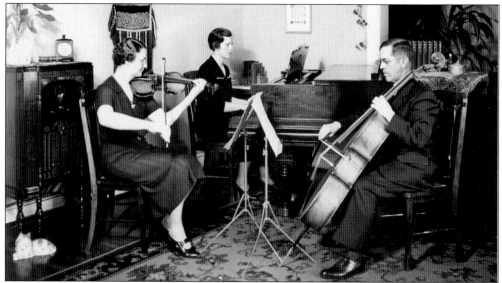

"Monday Musicals" was an informal group that periodically gathered together mainly in members' homes from the 1920s to 1950s to play and enjoy music. The musicians featured at this gathering on May 7, 1937, at the Maryland School for the Deaf are, from left to right, Cordelia Bjorlee, Margaret Kent, and Francis B. Sappington. Annual planning meetings to decide the style and dates of upcoming musicals took place in Mr. Sappington's home.

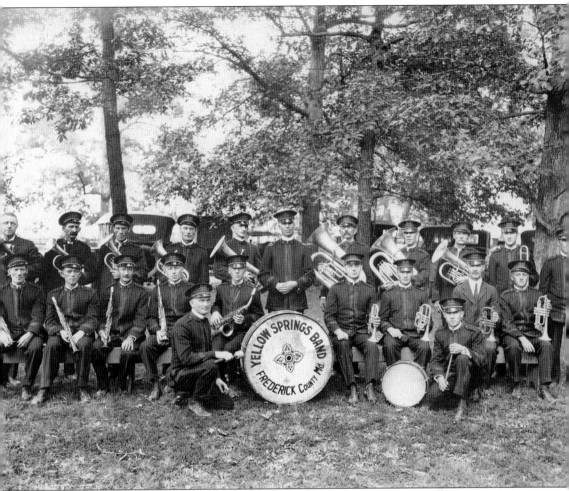

Members of the Yellow Springs Band took a break from entertaining picnickers at Utica in 1920. Bands were an extremely popular form of entertainment during the period, and a number of Frederick County communities, both large and small, fielded bands. The Yellow Springs Band was first started in early 1888 in Charlesville by Granville Stull. Later that year, it moved to Yellow Springs and adopted that village's name. Any fees the band collected—often between $12 and $19 a day from playing at barbecues, political meetings, parades, and picnics—were used to purchase instruments, uniforms, and new music. When the band was playing at a picnic, they would stand in a circle with the leader in the center directing.

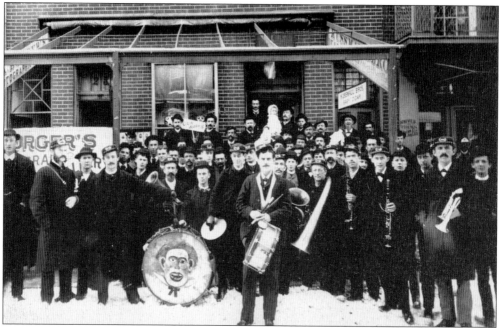

Photographer William Burger and dentist Edward Nelson, who shared this building with Charles Kussmaul's tobacco shop on North Market Street in Frederick, probably had to endure some loud and discordant noises from their neighbor. Spilling out of the tobacconist's front door are members of the "Babys," a social club that used the store as their meeting place. The improbable name of the club came from Kussmaul's famous baby cigar.

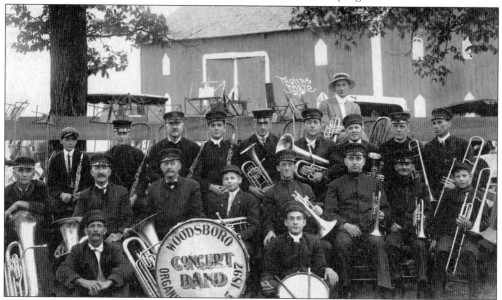

Reno Crum, in his smart straw hat, looks over Woodsboro's concert band. Pictured here from left to right are (front row) Pearce Strine and Ed Wallace; (middle row) Walter Smith, William H. Smith, James M. Smith, Cramer Powell, Hirsch Eichelberger, Ben Saxten, J. William Eyler, and William Powell; (back row) Robert Eyler, Roy Strine, Professor Harvey, Lynn Smith, Oscar Whitmore, Charlie Wills, Raymond Smith, Joe Price, and Luther Powell.

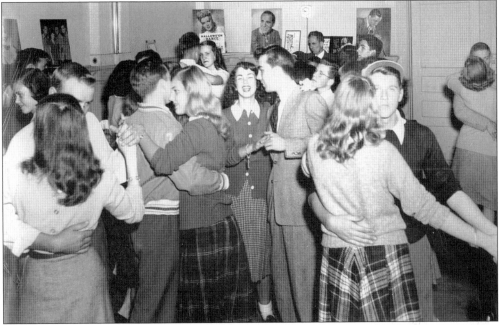

Images of several of the country's most popular musicians of the period look down upon these bobbysoxers at a Halloween dance at the Frederick YMCA on October 30, 1947. Even by the standards of the day, there was plenty of time for fun—the small electric clock in the background displays the time at about 9:45.

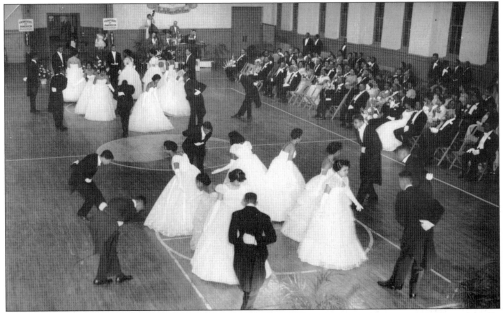

In April 1960, the Frontiers of America, an African-American service organization locally chartered in 1950, held its annual cotillion at the Frederick Armory. Young ladies dressed in white danced the night away with their tuxedoed escorts. George P. Ambush was president of the organization, and George E. Dredden acted as master of ceremonies for the evening. Bernice Monroe of Baltimore was the choreographer. Event proceeds benefited national health causes.

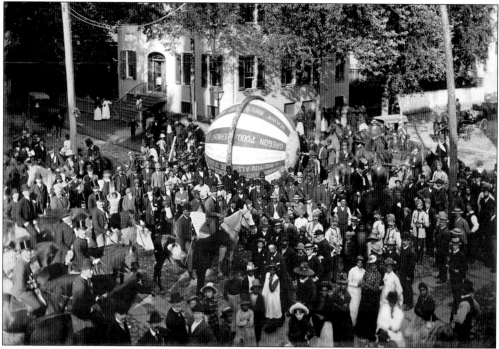

A large campaign ball rolled through Frederick, here at the corner of Church and Court Streets, in 1888. The ball was pulled by hand from state to state in support of Benjamin Harrison's campaign for President against Grover Cleveland, the incumbent. The Republicans intended the ball to represent a landslide victory for their candidate, who did win the election that year. Four years later, Cleveland won back the presidency.

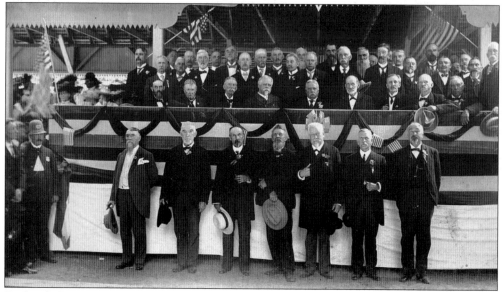

Frederick County Democrats held a rally at Wildwood Park in Mount Airy to support Edwin A. Warfield during his gubernatorial campaign of 1903. Warfield is the man with a white goatee and moustache near the middle of the row of seated gentlemen. He won the election and served one term as Maryland's governor between 1904 and 1908.

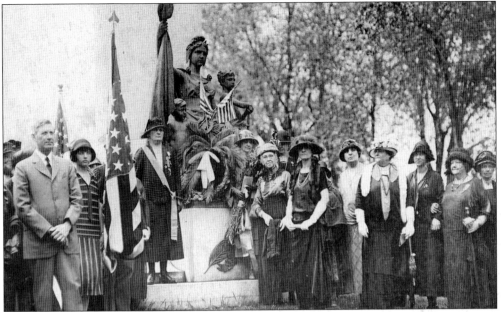

Mayor Lloyd Culler (left) was in attendance at this patriotic celebration at the Francis Scott Key Monument in Frederick's Mount Olivet Cemetery, c. 1920. The monument was the work of Pompeo Coppini, an Italian artist with the New York firm of Alexander Doyle. The base of the monument features allegorical figures representing patriotism, war, and music. The Francis Scott Key Monument has been the centerpiece of patriotic events for over a century.

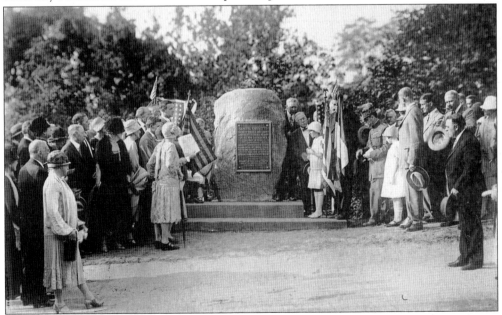

On September 17, 1926, the Sergeant Everhart Chapter of Sons of the American Revolution sponsored the dedication of a six-ton boulder bearing a plaque commemorating the Marquis de Lafayette's 1824 visit to Frederick. The monument was placed near Jug Bridge, on the Monocacy River's west bank, marking the point where locals greeted Lafayette upon his arrival. It was later relocated near the Interstate 70/Route 144 interchange east of Frederick.

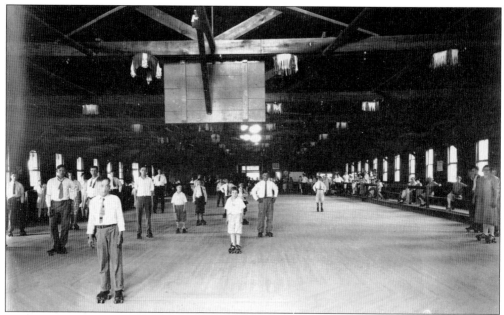

Braddock Heights Amusement Park was a popular attraction from 1896 to the 1960s, hitting its heyday in the 1920s. It was established by the Frederick Railway. The Park's Casino building featured the skating rink pictured here on the top floor, as well as a bowling alley and carnival games on the lower floor. In 1998, this oldest continuously operating roller rink in the United States fell victim to arson.

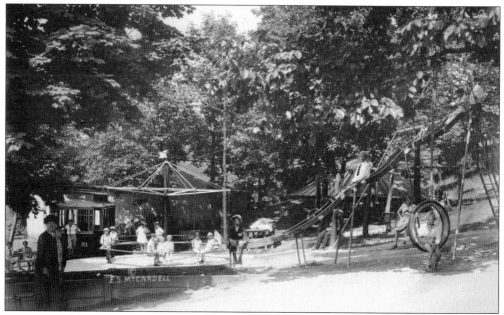

Over the years, new attractions were added to Braddock Heights Park. At one time or another, it included an auditorium that hosted hymn sings, Chautauquas, and silent movies, and later was home to the Mountain Theater, dance pavilion, indoor carousel, boat rides, miniature steam train, ferris wheel, and giant wooden slide, among other amusements. Pictured is a playground at the park c. 1910.

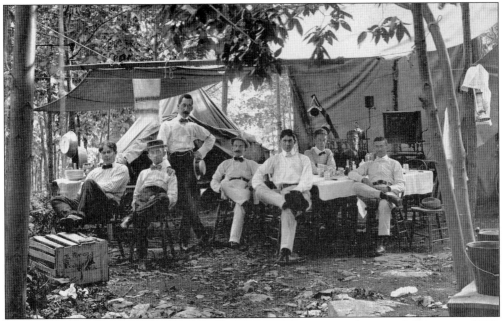

This group of fine fellows kicks back and relaxes at a camp somewhere in the county c. 1900. By the look of their attire, you might not guess they are "roughing it." Camping at the turn of the century, then becoming a popular pastime, meant moving dishes, chairs, and even stoves to the woods. The crate is stamped "D. Bros., Frederick" and likely carried provisions from Doll Brothers dry goods store.

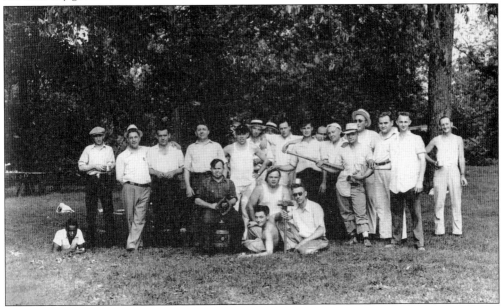

Employees of Kauffman's Garage, located on East Patrick Street in Frederick, posed for this photograph at one of their annual outings at Derr's Woods in the 1930s. Displayed is evidence of a few activities often enjoyed at company and family picnics even today: playing horseshoes and baseball and, of course, imbibing cold beverages. One wonders how the sledge hammer so prominently displayed was used.

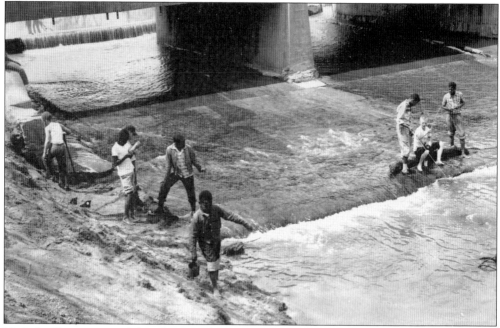

Nicholas Yinger snapped this photograph—on which he remarked, "The big one got away"—at Carroll Creek's College Avenue bridge in Baker Park, Frederick, on April 20, 1958. The boys at the center of the photo are fishing at what the photographer considered a particularly good spot to catch suckers traveling from the Monocacy River up the creek to spawn.

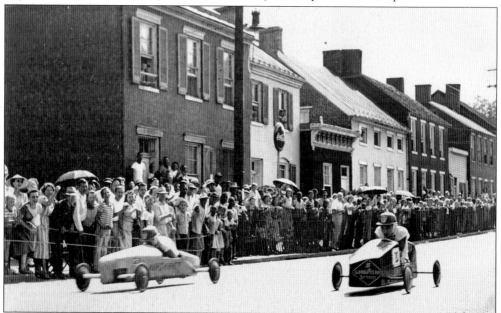

Two contestants in the Tri-County Soap Box Derby race along West Patrick Street in Frederick during one of the derby's heats in 1960. Boys between 11 and 15 constructed gravity-powered cars and raced locally for the opportunity to enter the national competition in Akron, Ohio. Their cars were sponsored by local businesses. Contest rules stipulated that the combined weight of the car and driver could not exceed 250 pounds.

Eight

THE CIVIL WAR

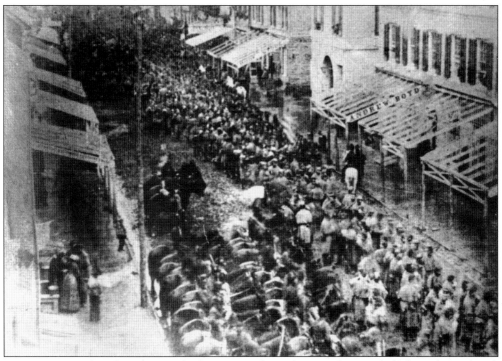

U.S. troops under the command of Gen. Nathaniel P. Banks paraded through Frederick down Market Street on February 22, 1862, for the city's celebration of Washington's Birthday. Jacob Engelbrecht, who recorded the spectacle in his diary, placed the number between 4,000 and 5,000. Two days later, Banks's troops were sent to Virginia, where, over the following months, they clashed repeatedly with Confederate forces under the command of Gen. Stonewall Jackson.

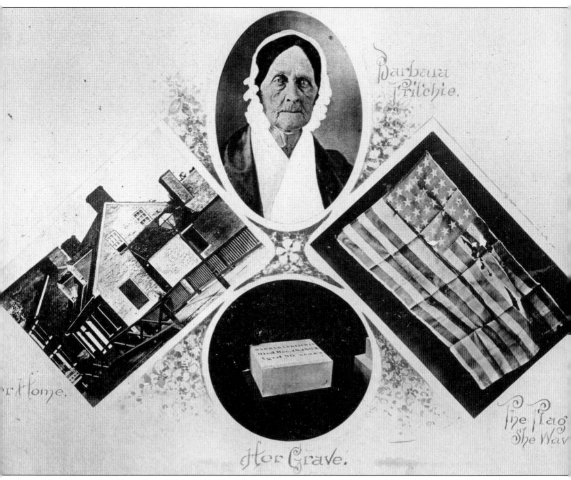

Barbara Fritchie, the subject of this photo montage, would have little believed that she would become a local legend when she died in December 1862 at the age of 96. Several months later, in 1863, John Greenleaf Whittier published a poem in *The Atlantic Monthly* in which he told of the heroic exploits of a character sharing her name. The alleged event, waving an American flag in the face of an army of Confederates marching through Frederick in 1862, has been proven apocryphal. Nevertheless, the romantic tale persisted and led to the reconstruction of her house in the 1920s and the use of her name to market everything from candy and soda to wallpaper and motorcycle races.

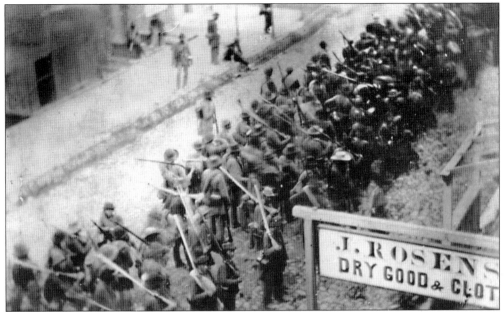

Jacob Rosenstock's store, located at the corner of Market and Patrick Streets, was in operation only eight years when it provided a vantage point for the photographer who captured these Confederate soldiers in Frederick. Taken that fateful September 1862, as the rebel army marched west to encounter Union forces at South Mountain and eventually Antietam, this is believed to be the only extant photograph of Confederate soldiers in column of march.

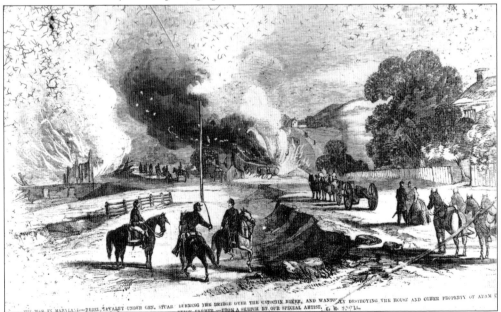

This engraving of the Battle of South Mountain from *Harper's Weekly* depicts the burning of the bridge over Catoctin Creek by Gen. J.E.B. Stuart's Confederate cavalry in September 1862. On September 12, Special Orders No. 191 from Confederate general Robert E. Lee to Gen. D.H. Hill was found by two U.S. soldiers near Frederick, precipitating the Battle of Antietam, one of the bloodiest battles of the entire war.

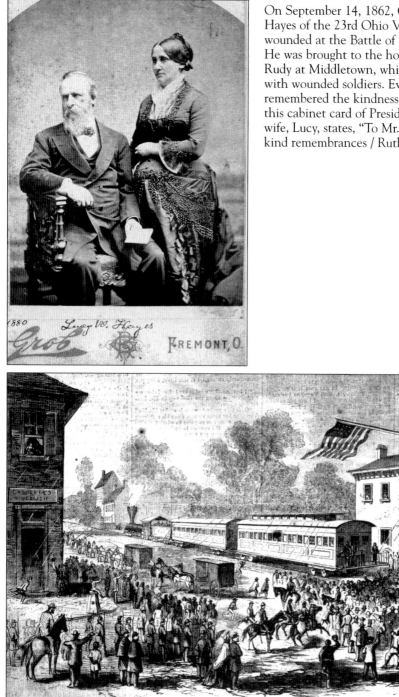

On September 14, 1862, Col. Rutherford Hayes of the 23rd Ohio Volunteers was badly wounded at the Battle of South Mountain. He was brought to the home of Capt. Jacob Rudy at Middletown, which was filling with wounded soldiers. Evidently, Hayes remembered the kindness. The reverse of this cabinet card of President Hayes and his wife, Lucy, states, "To Mr. Jacob Rudy / With kind remembrances / Rutherford B. Hayes."

The large U.S. flag flying from the Italianate-style B&O rail station in this illustration from *Harper's Weekly* points to the car on which President Abraham Lincoln stands to address the assembled crowd. Among the audience gathered on Market Street in Frederick that October day in 1862 are townspeople and members of the Army of the Potomac.

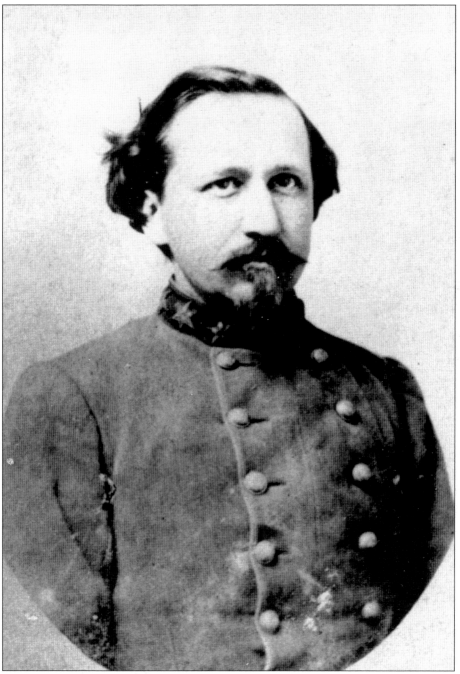

Bradley Tyler Johnson illustrates the divided loyalties of Frederick County residents during the American Civil War. Descended from two prominent Frederick County families, Johnson was a local militia officer before the war, but his sympathies were with the Confederacy. He actively recruited others in Maryland and formed his own company of cavalry. By the end of the war, he had become a brigadier general, but returning to his home proved to be difficult. He spent the remainder of his life managing the Maryland Confederate Soldiers' Home in Pikesville, Maryland. (Copy courtesy of the Library of Congress.)

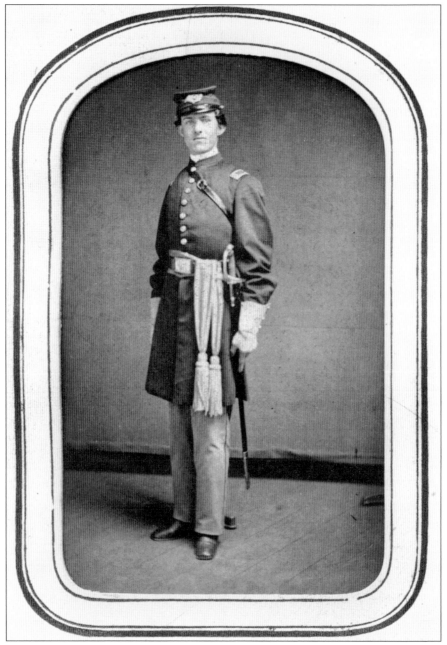

The Tyler family felt keenly the divisions of the Civil War. Pictured are Maria Tyler (opposite page, above) and her nephews Ira Tyler (opposite page, below) and George Tyler (above). Maria, 30 years old and a new mother when the war began, sympathized with the Confederate cause. She visited wounded Confederates in Frederick and began corresponding with several soldiers from North Carolina after they had been transferred to the federal prison at Johnson's Island, Ohio. Nevertheless, she still remained concerned with the welfare of her two nephews who remained with the Union. George Tyler joined the 7th Maryland Infantry in 1862 and was wounded in the Battle of the Wilderness in 1864. In recognition of his "gallant and meritorious conduct," he was brevetted captain on March 13, 1865.

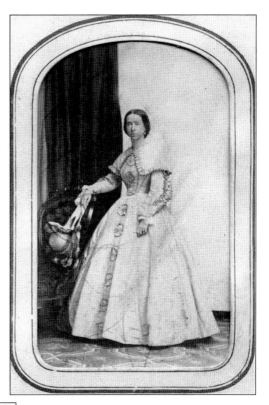

George's brother, Ira, a lieutenant, was captured at Winchester, Virginia, and was imprisoned at Libby Prison in Richmond. Maria's new Tar Heel friends had relatives in Richmond who made sure "Lt. Tyler" was looked after at "the Libby."

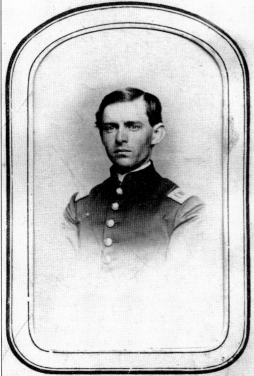

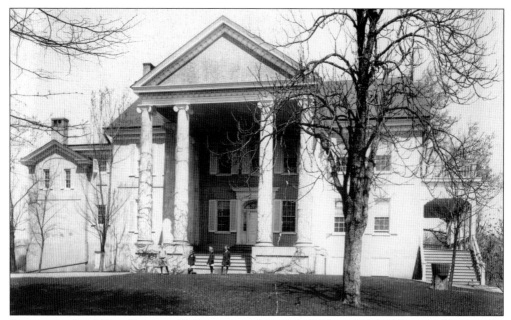

During the Civil War, Prospect Hall was owned by Col. William P. Maulsby, an officer in the Potomac Home Brigade. Both Confederate and Union troops encamped on the property at different times, and the mansion served as a hospital site after the Battle of Monocacy in 1864. In 1957, the property was acquired by the Roman Catholic Church and extensively remodeled for use as a school, St. John's Literary Institution.

NOTICE!

With feelings of deep regret, I have to announce to the citizens of Frederick, the melancholy intelligence of the assination of President LINCOLN, on Friday night, the 14th instant, and therefore respectfully request that the business places in this city, be closed from 12 o'clock, M., TO-DAY, and that appropriate public services be held in the different Churches at 4 o'clock, P. M., as a mark of respect for the deceased.

J. ENGELBRECHT,
Mayor.

Mayor's Office, April 15th, 1865.

Unionist Jacob Engelbrecht was mayor of Frederick when President Abraham Lincoln was fatally struck down by an assassin's bullet on Good Friday, April 14, 1865. Handbills like the one shown were distributed the next day. In his diary, Engelbrecht frequently commented on the war's progress. On July 31, 1865, while lamenting the nation's tremendous war debt, he added, "Still the Union of this government is cheap even at that price."

Pennsylvania governor John S. Fisher (second from left) helps Marilynn and Katrina Himes of Frederick unveil a historic marker on the grounds of Prospect Hall on June 28, 1930. The marker, made from a stone taken from "Devil's Den" on the Gettysburg Battlefield, commemorates the place where Maj. Gen. George Gordon Meade took command of the Union Army of the Potomac just days before the decisive battle in 1863.

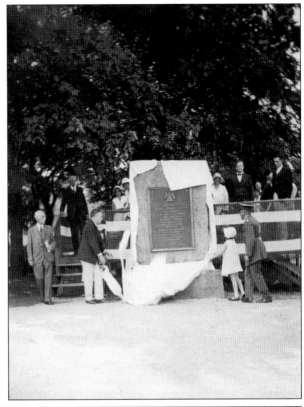

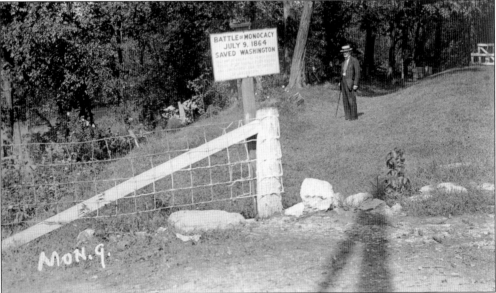

The lone figure sporting the boater hat and cane may have been the first to observe the anniversary of the Battle of Monocacy after the battlefield had become a national military park. On June 21, 1934, President Franklin D. Roosevelt signed legislation authorizing the land south of Frederick to be developed as a park and to preserve its historical features. The photograph was taken two weeks later on the battle's 70th anniversary.

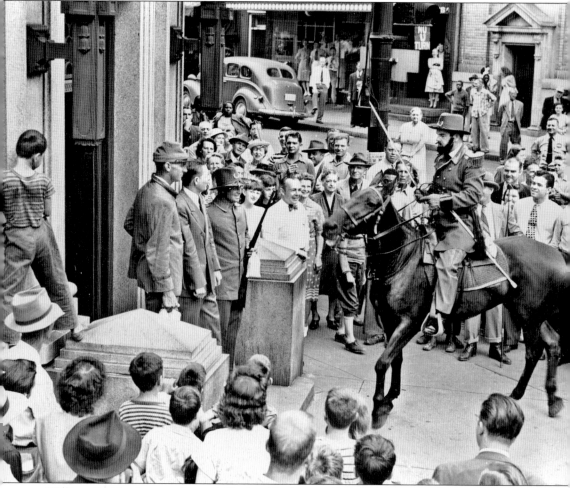

William E. Hardy, president of Frederick's Junior Chamber of Commerce, is dressed as Confederate general Jubal Early as he participates in the reenactment of the ransoming of Frederick on July 10, 1947. The event marked the 83rd anniversary of the day in 1864 when the Confederate army demanded and received $200,000 from the City of Frederick. Not beholden to historical chronology, the amused onlookers then streamed down Patrick Street to witness "Barbara Fritchie" wave her immortal flag and later retired to the grounds of the Maryland School for the Deaf to observe a re-creation of the Battle of Monocacy.

Nine

PEOPLE

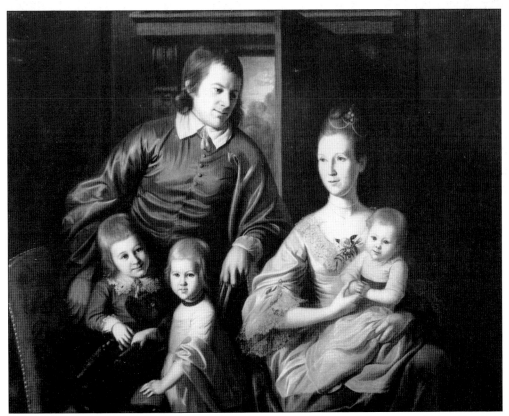

The family portrait of Maryland's first elected governor, Thomas Johnson, and his wife, Ann Jennings Johnson, was painted in the early 1770s by Charles Wilson Peale. The children, from left to right, were Thomas Jennings Johnson, Ann Jennings Johnson, and baby Rebecca. Thomas Johnson later served as an associate justice of the U.S. Supreme Court. (Permission to publish granted by the Trustees of the C. Burr Artz Library.)

John Fessler Jr. and his wife, Susan Baer Fessler, stared into the camera about 1860. Like his father, Fessler was a clockmaker in Frederick. For many years, he served as the city's official winder of the town clock, located in the steeple of what is known today as Trinity Chapel on West Church Street. Tall case clocks by both Fesslers can be seen at the Historical Society's museum.

Dr. William Bradley Tyler was born in Prince George's County, Maryland, in 1788. After studying with Frederick physician Philip Thomas, he went on to receive his medical degree from the University of Pennsylvania in 1809. Tyler practiced medicine in Frederick between 1814 and 1842 and died in 1863.

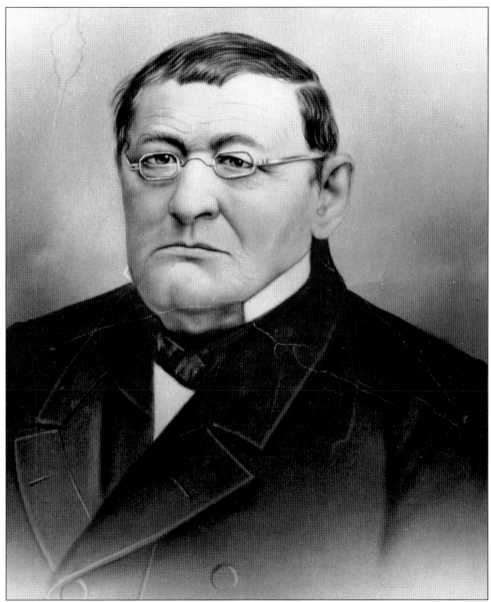

Jacob Engelbrecht was many things during his long life: a tailor, shopkeeper, and mayor, as well as an amateur weatherman, gardener, musician, and staunch Unionist during the Civil War. Perhaps most importantly, he always was a reporter. From 1818 until his death in 1878, he recorded the happenings in and around Frederick on the pages of his hand-bound diary, covering more than 20 volumes. Election coverage, foreign affairs, and commentary on issues and events of the day, as well as community births, deaths and marriages, and more, are all there. Jacob was born to Conrad and Margaret (Ramsburg) Engelbrecht in 1797. His father had come to this country as a German mercenary in the employ of the British during the War for Independence. Captured at Yorktown in 1781, he was imprisoned at the Hessian Barracks in Frederick and decided to stay after the war. Jacob Engelbrecht's diary provides an unequaled window to view 19th-century Frederick County for, as the diarist said, "the information of posterity."

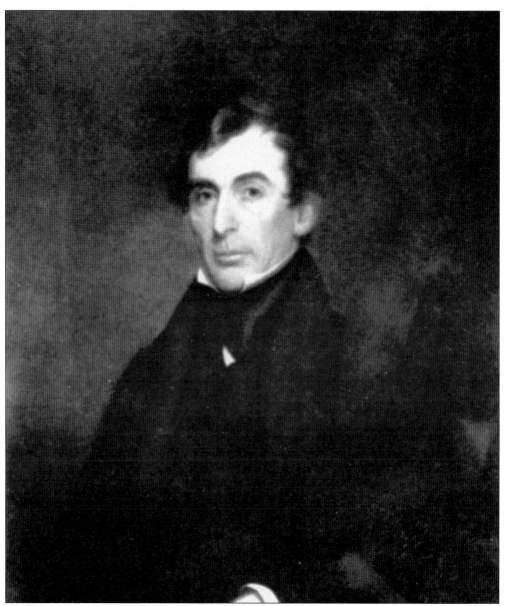

Roger Brooke Taney served as chief justice of the United States from 1836 until his death at age 87 in 1864. He began his legal career and nurtured political ambitions as a young attorney in Frederick. In his memoirs, Taney remembered his "inducement for selecting Frederick was that, next to Baltimore and Annapolis, it was, with a view toward profit, the best place of practice in the state." In 1806, Taney wed Ann Key, sister of his close friend Francis Scott Key. After leaving Frederick County in 1823, Taney served as the attorney general both for Maryland and the United States, secretary of the treasury in the Jackson administration, and eventually took a seat on the Supreme Court. During his long tenure as Chief Justice, Taney presided over many important legal cases. In 1857, he rendered the controversial majority opinion in the case of *Dred Scott v. Sanford*, pushing the nation closer to civil war. Taney served another seven years on the bench, clashing with President Abraham Lincoln over the limits of executive authority throughout the Civil War.

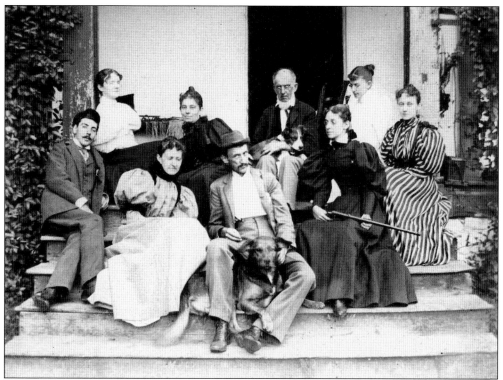

Thomas Gorsuch is the older man with the white beard and dog in the center of the c. 1895 family photograph made on the porch of Catoctin Manor, the former iron master's home at Catoctin Furnace. Gorsuch acquired the furnace about 1891, expanded its iron production, and added a paint manufactory. His son, Harry Peyton Gorsuch, is seated in the center of the front row.

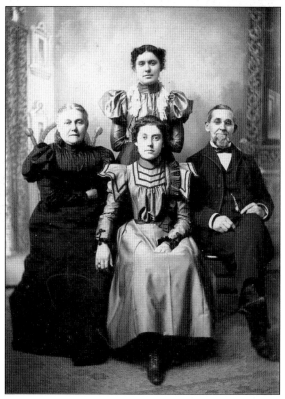

In this c. 1900 family portrait taken at the John D. Byerly studio in Frederick, Mary and John Lambert Michael flank their daughters, Bess (seated) and Pearl. Papa Michael seems especially proud. Mr. Michael was born in Buckeystown District in 1836. He opened his first grocery store in 1869 in Frederick and continued in the grocery business for over 40 years. Mrs. Michael was the former Mary Custard of Burkittsville.

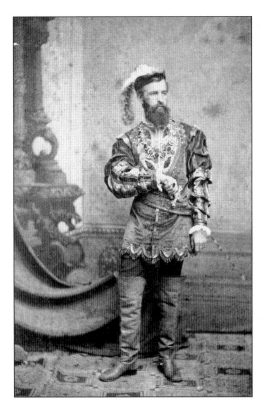

George Edward Smith (1850–1927) was considered one of the foremost musicians in Frederick County and one of the greatest baritones in the nation during his time. Here he is shown in the role of Count di Luna in *Il Trovatore* performed in Frederick in 1882. A staunch Democrat, he served as mayor of Frederick from 1901 to 1910.

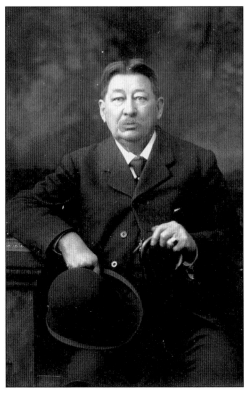

George Alfred Townsend (1841–1914) is best known for the War Correspondents Memorial Arch he erected about 1896 on his mountaintop estate, now known as Gathland State Park in western Frederick County. Townsend, a newspaper journalist known as "Gath," covered the Civil War and wrote an investigative piece called "The Life, Crimes, and Capture of John Wilkes Booth," whom he had interviewed a few weeks before Booth's assassination of President Lincoln.

Adm. Winfield Scott Schley (1839–1911), raised in Frederick and named for Mexican War hero and family friend Gen. Winfield Scott, enjoyed a 47-year career in the navy. He achieved widespread notoriety when, as commander of the blockading U.S. fleet, he destroyed the Spanish fleet at Santiago Harbor, Cuba, in 1898. Within days, Schley was being celebrated in word and song as one of the heroes of the Spanish-American War.

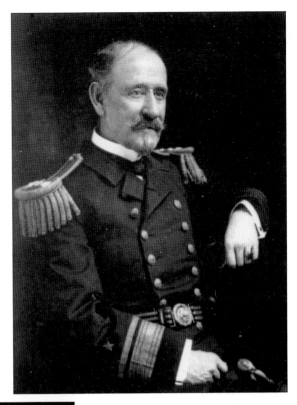

Kid Albert, a young athlete, assumed a boxing pose for his photograph. Boxing matches were held regularly by the Frederick Athletic Club and the YMCA boxing and wrestling club in the early 1900s. Boxers mentioned in an early newspaper article included Kid Jasper, Kid Reason, and Bully Atkins. Lloyd Jeffries managed the matches that were held in the Junior Hall on North Market Street in Frederick.

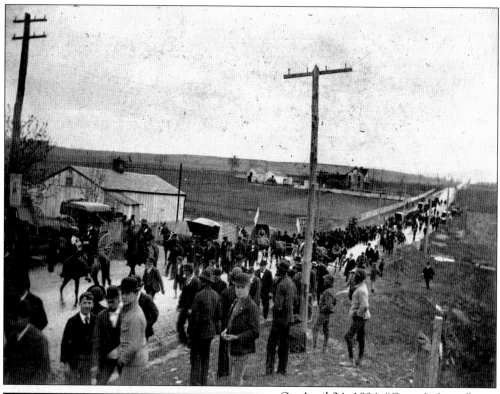

On April 24, 1894, "Coxey's Army," an army of over 500 unemployed men marching from Ohio to Washington, D.C., and led by James Coxey, entered Frederick observed by Sheriff D.P. Zimmerman. Coxey reported that his army was "so warmly greeted by handsome ladies that it was with difficulty our pickets could keep them back." In fact, they enjoyed hospitality and picked up several dozen marchers on their trek through Frederick County.

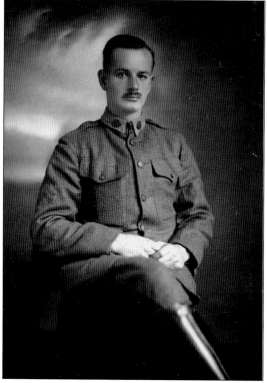

Carroll H. Hendrickson Sr. enlisted in the U.S. Army in 1917 during World War I. A sergeant when this photograph was taken, he served in the 110th Field Artillery and was a second lieutenant by the time he was discharged in 1919. That year, he married Mary Landon Carter Mason. Upon his father's death in 1921, he took over Hendrickson's, the family dry goods store on Market Street in Frederick.

Mildred Lee Purdy, daughter of Mr. and Mrs. Garrett Purdy of Frederick, was chosen as Miss Frederick in August 1924 at the competition held at the City Opera House. She went to Atlantic City in September to compete in the Miss America contest. She said that the Miss Frederick competition was the first time she had worn a bathing suit.

Elizabeth Harner Apple (1900–1998) married Russell McCain on April 15, 1926. Elizabeth was born at Hood College, in what is now Winchester Hall, in 1900, from where she graduated in 1923. Her father, Joseph Apple, who was president of the college for 41 years, is credited with introducing field hockey to women's colleges in this country. Elizabeth McCain was active at Hood College throughout her life.

This *c.* 1936 photograph of Ruanna Davis and her mother, Anna Mary Sprow, was taken at their home on Kleinhart's Alley in Frederick. Anna Sprow was born to Moses and Rachel Brown near Harmony Grove about 1845. She was a slave. As a young girl she was given by Joshua Dill to his daughter as a wedding gift. After gaining her freedom, she worked as a domestic. She died at age 91 in 1939.

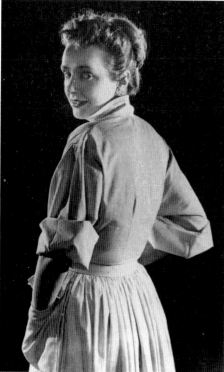

A Frederick native, Claire McCardell (1905–1958) attended Hood College and graduated from the New York School of Design in 1928. From that point, she was off, as she herself put it, "to save the world from ugliness and dreary clothes." Claire McCardell went on to become one of the country's most influential designers, her outdoor and sports styles revolutionizing American fashion and introducing the "casual look" that endures today.

Congressional candidate Charles "Mac" Mathias, on the left, and President Dwight D. Eisenhower wear "Back Mac" campaign buttons in the shape of black-eyed susans during Eisenhower's c. 1960 visit to the Mathias farm. Mac Mathias served Frederick County and the state for many years in the U.S. House and Senate; his son Charles is on the right.

These underage inmates are posing in a holding cell at the Maryland State Police Barracks B, located on West Patrick Street and Baughman's Lane in Frederick in May 1962. The "jailbirds" are, from left to right, Kenney Fink, Gary Davis, Denney Fink, Keith Davis, and Ronald Davis. The barracks moved to the Frederick County Law Enforcement Center on Airport Drive in 2002.

Judge Edward S. Delaplaine and Helen Smith posed in 1982 near the Utica covered bridge in northern Frederick County to commemorate the release of a limited edition print of the bridge based on a drawing by Miss Smith. Judge Delaplaine wrote a history of the bridge that accompanied the lithograph. Edward Delaplaine (1893–1989) was the chairman of the board of the parent company of the *Frederick News-Post*, which his father founded, as well as an acclaimed Maryland jurist. He had a tremendous impact on the preservation of the county's heritage through his research, writing, and philanthropic work. His published works include biographies of Thomas Johnson and Francis Scott Key, and he was a leader in the preservation of the Roger B. Taney House. Artist Helen Smith (1894–1997) taught at Hood College from 1916 to 1925. In 1925, she opened an art and gift shop in Frederick, later moving to Braddock Heights. She completed many commissions, often inspired by her love of nature, and achieved national acclaim for her 1985 restoration of *Justice*, a work she created in 1924.

Ten

PLACES

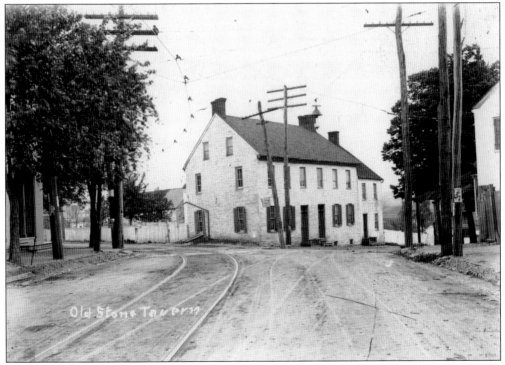

The Old Stone Tavern was located on the southwest corner of Patrick and Jefferson Streets in Frederick in an area known as "Battletown." The tavern is purported to have provided respite and refreshment to an assortment of historical figures, including George Washington, Daniel Webster, and Andrew Jackson. It was demolished in 1927 to build a service station.

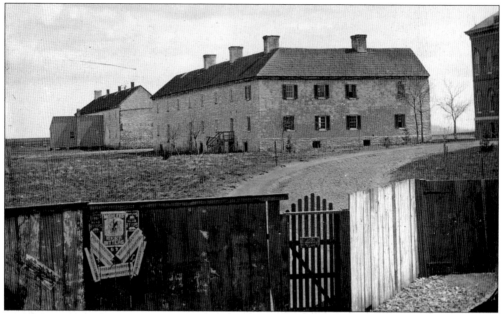

Built by Abraham Faw after the outbreak of the American Revolution, the "Hessian Barracks" in Frederick was originally intended as housing for American troops. The buildings instead housed German prisoners and later served as an arsenal. Classes for deaf students began there in 1868 until the construction of the new Maryland School for the Deaf in 1872–1873. The building in the background at left still stands on the school grounds.

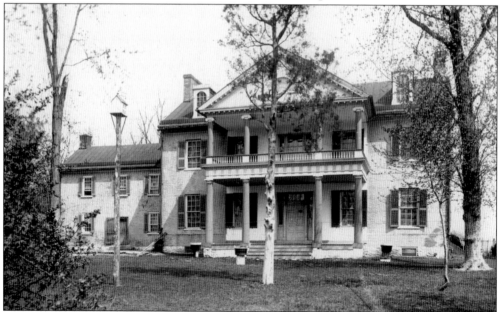

Maj. and Mrs. John Graham built Rose Hill Manor in the 1790s on land given to the couple as a wedding present from Maryland governor Thomas Johnson, the bride's father. Governor Johnson lived his last 25 years at the estate. In 1969, Frederick County purchased the property to build Governor Thomas Johnson High School. The remaining acreage was developed into Rose Hill Manor Park, which includes a children's museum.

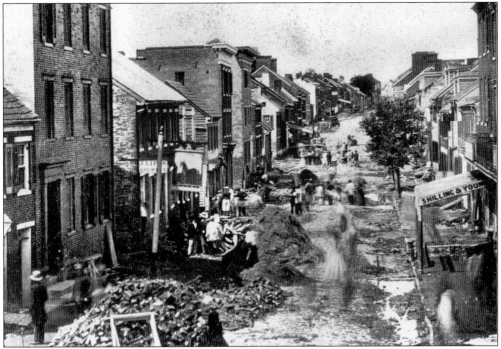

After an extended drought, rain began falling on July 23, 1868. By the next morning, it had become a torrent that lasted all day. Water in Carroll Creek in Frederick rose so rapidly that people had no time to save belongings as they rushed to higher ground. No lives were lost locally, but property damage amounted to half a million dollars. Shown here is West Patrick Street in the aftermath.

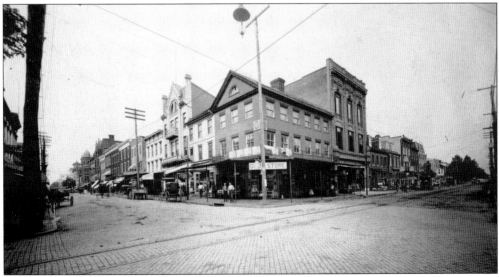

Dr. S. Frank Thomas, both physician and druggist, operated a drug store on the northeast corner of Market and Patrick Streets, known as the "Square Corner," in Frederick for 20 or more years. After Thomas's death in 1907, the property was purchased by C. Thomas Kemp, who razed the building and built a new department store. On the National Road, this intersection was arguably the county's most prime real estate.

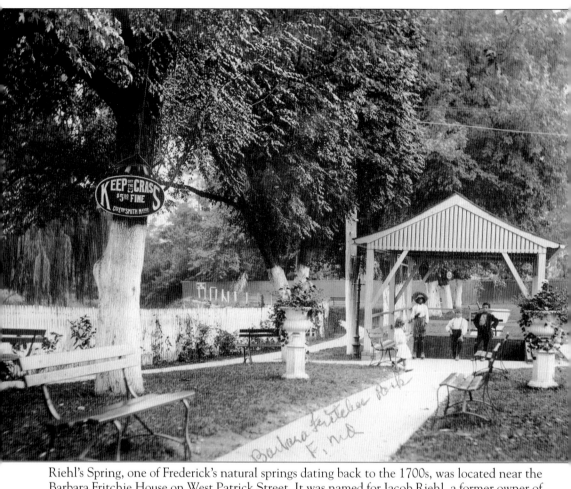

Riehl's Spring, one of Frederick's natural springs dating back to the 1700s, was located near the Barbara Fritchie House on West Patrick Street. It was named for Jacob Riehl, a former owner of the property. By 1830, the spring had been acquired by the city, which made extensive repairs and opened it to the public. In 1907, the space was opened as Carroll Park. Apparently, Mayor George Edward Smith was serious about keeping people off the grass at the time this photograph was taken about two years later. In the 1920s, the Barbara Fritchie Home Association erected a canopy over the spring. By 1982, the spring was nearly dry and was redirected to make way for the Carroll Creek Project. The Carroll Creek Project is intended to spare Frederick devastation like that wrought by the several major floods that have occurred in the city's history, most recently in 1976.

Prominent jeweler and watch repairer H.S. Landis had two stores on Market Street in Frederick. In 1902, Middletown's *The Valley Register* announced that he "is having a handsome mosaic clock watch sign placed on the pavement at his North Market Street jewelry store." Advertisements at the time noted he was a "Watch Inspector" for the B&O Railroad. Today, a similar mosaic survives at the site of the original Landis store on South Market Street.

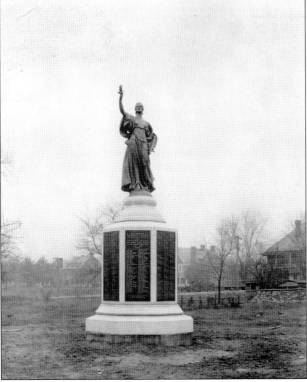

Memorial Ground (or Park) is located on the northwest corner of West Second and North Bentz Streets in Frederick. Originally the graveyard of the German Reformed Church, it was conveyed to the City of Frederick in 1924. That year, a monument topped by the bronze figure of Liberty was erected and dedicated "in honor of the sons and daughters of Frederick County who served their country in the Great World War" (1917–1918).

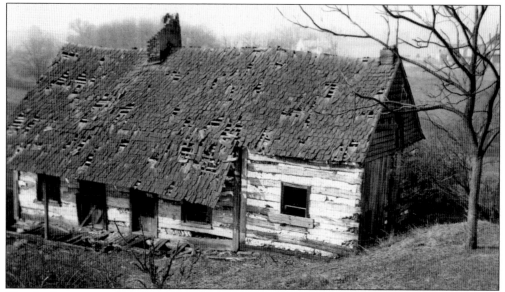

This log house once located about a mile south of Feagaville (pronounced Fee-gee-ville) was captured on film in 1953. It probably dated back to the early settlement of the area. Although the area had a preponderance of Culler family members throughout the 19th century, the village was named for Charles Edward Feaga, who established its first general store in 1885 and served as the first postmaster.

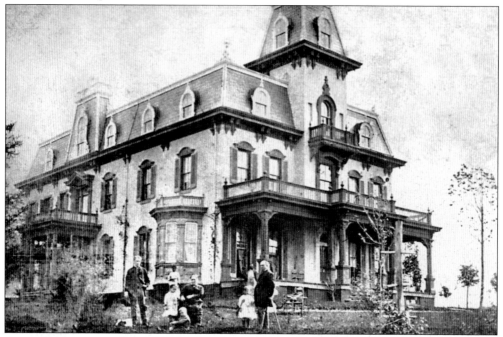

Gambrill House, or Edgewood Mansion, was built in 1872 by James H. Gambrill Sr. on land he purchased that adjoined his Araby Mill. The property was the site of fighting during the Battle of Monocacy in July 1864. James Gambrill stands to the right in this photograph, and the seated woman is likely his wife, Antoinette (Staley) Gambrill. Their home was the site of major social functions for 25 years.

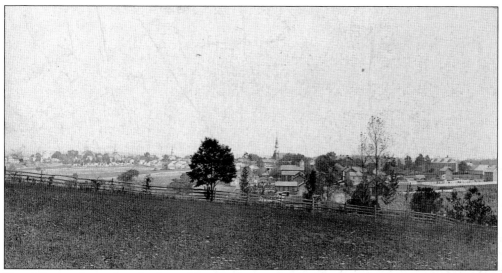

Emmitsburg is located at the foot of the Catoctin range on the county's northern end. In 1785, Samuel Emmit transferred 35 acres of a large land tract he had purchased in 1757 to his son, William, "wherein the lots of a new town called Emmitsburg are laid out." By 1786, foundations were being laid in the town, which was granted a charter by the Maryland General Assembly in 1825.

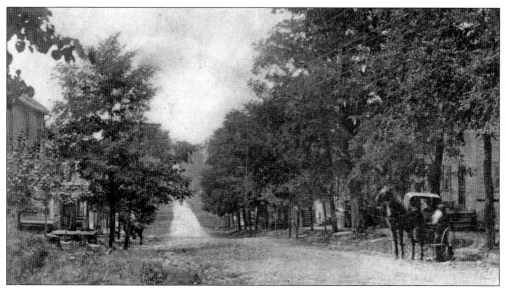

Libertytown was established in 1782 when John Young divided part of his tract, "Duke's Woods," into 240 building lots. The town's name is believed to have come from the Sons of Liberty organizations. Pictured is Main Street, or Liberty Road (Route 26), c. 1890s. The town boasted many fine houses as well as taverns and inns catering to carriage trades.

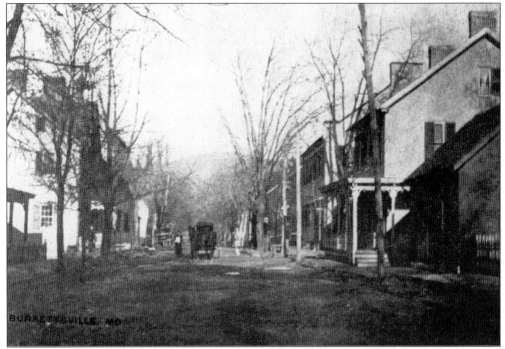

When this image was made *c.* 1890s, Burkittsville boasted two dry goods stores, a butcher, a tailor, a blacksmith, a druggist, and even an undertaker/cabinetmaker, among other businesses. First known as Harley's Store, the burg was more formally named for its largest land owner, Henry Burkitt, in the early 1800s. Its location, almost midway between Brunswick and Middletown, provided a convenient stop for local farmers, railroad workers, and travelers.

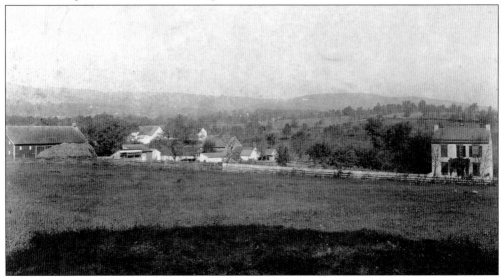

"The mountain walls in blue and brown / Hark to the bells of Middletown, / And far and wide their notes of peace / Bid suffering and sorrow cease"—so wrote T.C. Harbaugh in his 1910 book *Middletown Valley in Song and Story*. Middletown was incorporated in 1884 and by 1900 had a population of over 600. Harbaugh, author of many dime novels, was born in Middletown and often wrote of the Middletown Valley.

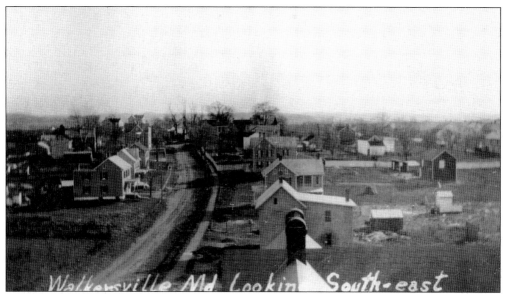

The town of Walkersville was incorporated in 1892, though its beginnings predate that by decades. Local tradition traces the present-day town to the merging on Main Street of two villages, Walkersville, which grew along Route 194, and Georgetown, which grew along Biggs Ford Road. In 1882, likely a few years before this image was made, property around Walkersville was selling for $75–$100 per acre.

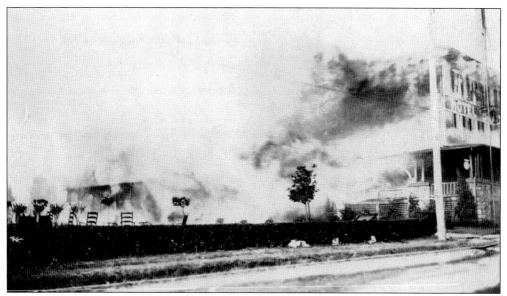

Hotel Braddock was built in 1905 at a cost of $1,500, partially subsidized by the Frederick & Middletown Railway, to capitalize on the popularity of Braddock Heights as a summer retreat. In the early morning of August 13, 1929, a desk clerk spotted smoke emanating from the upper floor. Though the local fire department responded quickly, the fire spread rapidly. With the popularity of the destination waning, the hotel was not rebuilt.

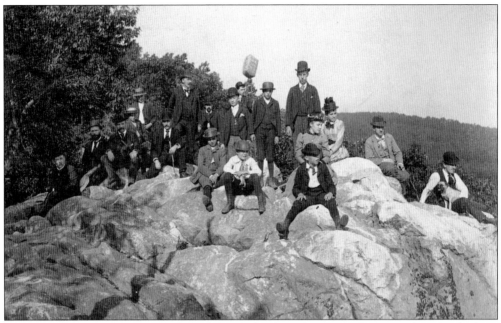

This group of hearty hikers posed for photographer by John D. Byerly atop White Rock about 1890. Perhaps the little dog at left served as security against the threat of rattlesnakes, which frequented the white quartz outcropping on Catoctin Mountain. The popular destination is located just west of Yellow Springs and offers views of Monocacy Valley, Sugar Loaf Mountain, the Potomac River, and even the Round Tops on the Gettysburg Battlefield.

In 1934, the City of Frederick presented a large tract of land to the State for the establishment of Gambrill State Park. At over 1,100 acres, the park was one of the state's most heavily visited by the 1950s when this snapshot was taken. The Middletown Valley can be seen from this overlook. Route 70 is now located just above the tree line in the center of this image.